Ananda K. Coomaraswamy

christian and oriental philosophy of art

Formerly titled

"Why Exhibit Works of Art?"

Dover Publications, Inc., New York

This Dover edition, first published in 1956, is an unabridged and unaltered republication of the work originally published by Luzac & Co., Ltd., in 1943 under the title *Why Exhibit Works of Art?*

Standard Book Number: 486-20378-6
Library of Congress Catalog Card Number: 57-3496

Manufactured in the United States of America
Dover Publications, Inc.
180 Varick Street
New York, N.Y. 10014

CONTENTS

ACKNOWLEDGMENTS

Chapter I. WHY EXHIBIT WORKS OF ART? An address delivered before the American Association of Museums at Columbus, Ohio, and Newport, R.I., in May and October, 1941, and printed in the *Journal of Æsthetics*, New York, Fall Issue, 1941.

Chapter II. THE CHRISTIAN AND ORIENTAL, OR TRUE PHILOSOPHY OF ART. A lecture delivered at the Walter Vincent Smith Art Gallery, and at Boston College, 1939, and printed as a *John Stevens Pamphlet*, Newport, 1939.

Chapter III. IS ART A SUPERSTITION OR A WAY OF LIFE? A lecture given at the Metropolitan Museum of Art, New York, April, 1937, and at Harvard University (Summer School), July, 1937. Printed in the *American Review* Summer Number, 1937, and as a *John Stevens Pamphlet* Newport, 1937.

Postscript. NOTE ON A REVIEW BY RICHARD FLORSHEIM. *Art Bulletin*, Vol. XX, New York, 1937.

Chapter IV. WHAT IS THE USE OF ART, ANYWAY? Two broadcasts for the Museum of Fine Arts, Boston, January, 1937. Printed in the *American Review*, February, 1937. and with other matter by A. Graham Carey and John Howard Benson as a *John Stevens Pamphlet*, Newport 1937.

Chapter V. BEAUTY AND TRUTH. *Art Bulletin*, XX, New York, 1938.

Chapter VI. THE NATURE OF MEDIÆVAL ART. From The *Arts of the Middle Ages*, Museum of Fine Arts, Boston, 1940.

Chapter VII. THE TRADITIONAL CONCEPTION OF IDEAL PORTRAITURE. *Twice a Year*, III-IV, New York, 1939, pp. 244-252 ; *Journal of the Indian Society of Oriental Art*, Calcutta, VII, 1939, pp. 74-82.

Chapter VIII. THE NATURE OF FOLKLORE AND POPULAR ART. *Qtly. Journal of the Mythic Society*, Bangalore, July-October, 1936 ; *Indian Art and Letters*, London, 1937 ; and (in French) *Études Traditionelles*, Paris, 1937.

Chapter IX. THE BEAUTY OF MATHEMATICS. A review ; *Art Bulletin*, Vol. XXIII, New York, 1941.

I

WHY EXHIBIT WORKS OF ART?

WHAT is an Art Museum for? As the word "Curator" implies, the first and most essential function of such a Museum is to take care of ancient or unique works of art which are no longer in their original places or no longer used as was originally intended, and are therefore in danger of destruction by neglect or otherwise. This care of works of art does not necessarily involve their exhibition.

If we ask, why should the protected works of art be exhibited and made accessible and explained to the public, the answer will be made, that this is to be done with an educational purpose. But before we proceed to a consideration of this purpose, before we ask, Education in or for what? a distinction must be made between the exhibition of the works of living artists and that of ancient or relatively ancient or exotic works of art. It is unnecessary for Museums to exhibit the works of living artists, which are not in imminent danger of destruction; or at least, if such works are exhibited, it should be clearly understood that the Museum is really advertising the artist and acting on behalf of the art dealer or middleman whose business it is to find a market for the artist; the only difference being that while the Museum does the same sort of work as the dealer, it makes no profit. On the other hand, that a living artist should wish to be "hung" or "shown" in a Museum can be only due to his need or his vanity. For things are made normally for certain purposes and certain places to which they are appropriate, and not simply "for exhibition"; and because whatever is thus

custom-made, i.e., made by an artist for a consumer, is controlled by certain requirements and kept in order. Whereas, as Mr. Steinfels has recently remarked, "Art which is only intended to be hung on the walls of a Museum is one kind of art that need not consider its relationship to its ultimate surroundings. The artist can paint anything he wishes, any way he wishes, and if the Curators and Trustees like it well enough they will line it up on the wall with all the other curiosities."

We are left with the real problem, Why exhibit? as it applies to the relatively ancient or foreign works of art which, because of their fragility and because they no longer correspond to any needs of our own of which we are actively conscious, are preserved in our Museums, where they form the bulk of the collections. If we are to exhibit these objects for educational reasons, and not as mere curios, it is evident that we are proposing to make such use of them as is possible without an actual handling. It will be imaginatively and not actually that we must use the mediæval reliquary, or lie on the Egyptian bed, or make our offering to some ancient deity. The educational ends that an exhibition can serve demand, accordingly, the services not of a Curator only, who prepares the exhibition, but of a Docent who explains the original patron's needs and the original artists' methods ; for it is because of what these patrons and artists were that the works before us are what they are. If the exhibition is to be anything more than a show of curiosities and an entertaining spectacle it will not suffice to be satisfied with our own reactions to the objects ; to know why they are what they are we must know the men that made them. It will not be "educational" to interpret such objects by our likes or dislikes, or to assume that these men thought of art in our fashion, or that they had æsthetic motives, or were "expressing themselves." We must examine *their*

theory of art, first of all in order to understand the things that they made by art, and secondly in order to ask whether their view of art, if it is found to differ from ours, may not have been a truer one.

Let us assume that we are considering an exhibition of Greek objects, and call upon Plato to act as our Docent. He knows nothing of our distinction of fine from applied arts. For him painting and agriculture, music and carpentry and pottery are all equally kinds of poetry or making. And as Plotinus, following Plato, tells us, the arts such as music and carpentry are not based on human wisdom but on the thinking " there."

Whenever Plato speaks disparagingly of the " base mechanical arts " and of mere " labour " as distinguished from the " fine work " of making things, it is with reference to kinds of manufacture that provide for the needs of the body alone. The kind of art that he calls wholesome and will admit to his ideal state must be not only useful but also true to rightly chosen models and therefore beautiful, and this art, he says, will provide at the same time " for the souls and bodies of your citizens." His " music " stands for all that we mean by " culture," and his " gymnastics " for all that we mean by physical training and well-being ; he insists that these ends of culture and physique must never be separately pursued ; the tender artist and the brutal athlete are equally contemptible. We, on the other hand are accustomed to think of music, and culture in general, as useless, but still valuable. We forget that music, traditionally, is never something only for the ear, something only to be heard, but always the accompaniment of some kind of action. Our own conceptions of culture are typically negative. I believe that Professor Dewey is right in calling our cultural values snobbish. The lessons of the Museum must be applied to our life.

Because we are not going to handle the exhibited

objects, we shall take their aptitude for use, that is to say their efficiency, for granted, and rather ask in what sense they are also true or significant ; for if these objects can no longer serve our bodily needs, perhaps they can still serve those of our soul, or if you prefer the word, our reason. What Plato means by "true" is "iconographically correct." For all the arts, without exception, are representations or likenesses of a model ; which does not mean that they are such as to tell us what the model looks like, which would be impossible seeing that the forms of traditional art are typically imitative of invisible things, which have no looks, but that they are such adequate analogies as to be able to remind us, i.e., put us in mind again, of their archetypes. Works of art are reminders ; in other words, supports of contemplation. Now since the contemplation and understanding of these works is to serve the needs of the soul, that is to say in Plato's own words, to attune our own distorted modes of thought to cosmic harmonies, " so that by an assimilation of the knower to the to-be-known, the archetypal nature, and coming to be in that likeness, we may attain at last to a part in that 'life's best' that has been appointed by the Gods to man for this time being and hereafter," or stated in Indian terms, to effect our own metrical reintegration through the imitation of divine forms ; and because, as the Upanishad reminds us, " one comes to be of just such stuff as that on which the mind is set," it follows that it is not only requisite that the shapes of art should be adequate reminders of their paradigms, but that the nature of these paradigms themselves must be of the utmost importance, if we are thinking of a cultural value of art in any serious sense of the word " culture." The *what* of art is far more important than the *how* ; it should, indeed, be the what that determines the how, as form determines shape.

Plato has always in view the representation of invisible

and intelligible forms. The imitation of anything and everything is despicable ; it is the actions of Gods and Heroes, not the artist's feelings or the natures of men who are all too human like himself, that are the legitimate theme of art. If a poet cannot imitate the eternal realities, but only the vagaries of human character, there can be no place for him in an ideal society, however true or intriguing his representations may be. The Assyriologist Andræ is speaking in perfect accord with Plato when he says, in connection with pottery, that " It is the business of art to grasp the primordial truth, to make the inaudible audible, to enunciate the primordial word, to reproduce the primordial images—or it is not art." In other words, a real art is one of symbolic and significant representation ; a representation of things that cannot be seen except by the intellect. In this sense art is the antithesis of what we mean by visual education, for this has in view to tell us what things that we do not see, but might see, look like. It is the natural instinct of a child to work from within outwards ; " First I think, and then I draw my think." What wasted efforts we make to teach the child to stop thinking, and only to observe ! Instead of training the child to think, and how to think and of what, we make him " correct " his drawing by what he sees. It is clear that the Museum at its best must be the sworn enemy of the methods of instruction currently prevailing in our Schools of Art.

It was anything but " the Greek miracle " in art that Plato admired ; what he praised was the canonical art of Egypt in which " these modes (of representation) that are by nature correct had been held for ever sacred." The point of view is identical with that of the Scholastic philosophers, for whom " art has fixed ends and ascertained means of operation." New songs, yes ; but never new kinds of music, for these may destroy our whole civilization. It is the irrational impulses that yearn for

innovation. Our sentimental or æsthetic culture—
sentimental, æsthetic and materialistic are virtually
synonyms—prefers instinctive expression to the formal
beauty of rational art. But Plato could not have seen
any difference between the mathematician thrilled by a
" beautiful equation " and the artist thrilled by his formal
vision. For he asked us to stand up like men against
our instinctive reactions to what is pleasant or unpleasant,
and to admire in works of art, not their æsthetic surfaces
but the logic or right reason of their composition. And
so naturally he points out that " The beauty of the
straight line and the circle, and the plane and the solid
figures formed from these . . . is not, like other things,
relative, but always absolutely beautiful." Taken to-
gether with all that he has to say elsewhere of the
humanistic art that was coming into fashion in his own
time and with what he has to say of Egyptian art, this
amounts to an endorsement of Greek Archaic and Greek
Geometric Art—the arts that really correspond to the
content of those myths and fairy tales that he held in such
high respect and so often quotes. Translated into
more familiar terms, this means that from this intellectual
point of view the art of the American Indian sand-
painting is superior in kind to any painting that has been
done in Europe or white America within the last several
centuries. As the Director of one of the five greatest
museums in our Eastern States has more than once
remarked to me, From the Stone Age until now, what
a decline ! He meant, of course, a decline in intellec-
tuality, not in comfort. It should be one of the functions
of a well organized Museum exhibition to deflate the
illusion of progress.

At this point I must digress to correct a widespread
confusion. There exists a general impression that
modern abstract art is in some way like and related to,
or even " inspired " by the formality of primitive art.

The likeness is altogether superficial. Our abstraction is nothing but a mannerism. Neolithic art is abstract, or rather algebraic, because it is only an algebraical form that can be the single form of very different things. The forms of early Greek are what they are because it is only in such forms that the polar balance of physical and metaphysical can be maintained. " To have forgotten," as Bernheimer recently said, " this purpose before the mirage of absolute patterns and designs is perhaps the fundamental fallacy of the abstract movement in art." The modern abstractionist forgets that the Neolithic formalist was not an interior decorator, but a metaphysical man who saw life whole and had to *live* by his wits ; one who did not, as we seek to, live by bread alone, for as the anthropologists assure us, primitive cultures provided for the needs of the soul and the body at one and the same time. The Museum exhibition should amount to an exhortation to return to these savage levels of culture.

A natural effect of the Museum exhibition will be to lead the public to enquire why it is that objects of " museum quality " are to be found only in Museums and are not in daily use and readily obtainable. For the Museum objects, on the whole, were not originally " treasures " made to be seen in glass cases, but rather common objects of the market place that could have been bought and used by anyone. What underlies the deterioration in the quality of our environment ? Why should we have to depend as much as we do upon " antiques " ? The only possible answer will again reveal the essential opposition of the Museum to the world. For this answer will be that the Museum objects were custom made and made for use, while the things that are made in our factories are made primarily for sale. The word " manufacturer " itself, meaning one who makes things by hand, has come to mean a salesman

who gets things made for him by machinery. The museum objects were humanly made by responsible men, for whom their means of livelihood was a vocation and a profession. The museum objects were made by free men. Have those in our department stores been made by free men? Let us not take the answer for granted.

When Plato lays it down that the arts shall " care for the bodies and souls of your citizens," and that only things that are sane and free, and not any shameful things unbecoming free men, are to be made, it is as much as to say that the artist in whatever material must be a free man ; not meaning thereby an " emancipated artist " in the vulgar sense of one having no obligation or commitment of any kind, but a man emancipated from the despotism of the salesman. If the artist is to represent the eternal realities, he must have known them as they are. In other words an act of imagination in which the idea to be represented is first clothed in an imitable form must have preceded the operation in which this form is to be embodied in the actual material. The first of these acts is called " free," the latter "servile." But it is only if the first be omitted that the word servile acquires a dishonourable connotation. It hardly needs demonstration that our methods of manufacture are, in this shameful sense, servile, or can be denied that the industrial system, for which these methods are indispensable, is unfit for free men. A system of " manufacture," or rather of quantity production dominated by money values, presupposes that there shall be two different kinds of makers, privileged " artists " who may be " inspired," and under-privileged labourers, unimaginative by hypothesis, since they are asked only to make what other men have imagined. As Eric Gill put it, " On the one hand we have the artist concerned solely to express himself ; on the other is the workman deprived

of any self to express." It has often been claimed that the productions of " fine " art are useless ; it would seem to be a mockery to speak of a society as free, where it is only the makers of useless things, and not the makers of utilities, that can be called free, except in the sense that we are all free to work or starve.

It is, then, by the notion of a vocational making, as distinguished from earning one's living by working at a job, regardless of what it may be, that the difference between the museum objects and those in the department store can be best explained. Under these conditions, which have been those of all non-industrial societies, that is to say when each man makes one kind of thing, doing only that kind of work for which he is fitted by his own nature and for which he is therefore destined, Plato reminds us that " more will be done, and better done than in any other way." Under these conditions a man at work is doing what he likes best, and the pleasure that he takes in his work perfects the operation. We see the evidence of this pleasure in the Museum objects, but not in the products of chain-belt operation, which are more like those of the chain-gang than like those of men who enjoy their work. Our hankering for a state of leisure or leisure state is the proof of the fact that most of us are working at a task to which we could never have been called by anyone but a salesman, certainly not by God or by our own natures. Traditional craftsmen whom I have known in the East cannot be dragged away from their work, and will work overtime to their own pecuniary loss.

We have gone so far as to divorce work from culture, and to think of culture as something to be acquired in hours of leisure ; but there can be only a hothouse and unreal culture where work itself is not its means ; if culture does not show itself in all we make we are not cultured. We ourselves have lost this vocational way

of living, the way that Plato made his type of Justice ; and there can be no better proof of the depth of our loss than the fact that we have destroyed the cultures of all other peoples whom the withering touch of our civilization has reached.

In order to understand the works of art that we are asked to look at it will not do to explain them in the terms of our own psychology and our æsthetics ; to do so would be a pathetic fallacy. We shall not have understood these arts until we can think about them as their authors did. The Docent will have to instruct us in the elements of what will seem a strange language ; though we know its terms, it is with very different meanings that we nowadays employ them. The meaning of such terms as art, nature, inspiration, form, ornament and æsthetic will have to be explained to our public in words of two syllables. For none of these terms are used in the traditional philosophy as we use them to-day.

We shall have to begin by discarding the term *æsthetic* altogether. For these arts were not produced for the delectation of the senses. The Greek original of this modern word means nothing but sensation or reaction to external stimuli ; the sensibility implied by the word *aisthesis* is present in plants, animals, and man ; it is what the biologist calls "irritability." These sensations, which are the passions or emotions of the psychologist, are the driving forces of instinct. Plato asks us to stand up like men against the pulls of pleasure and pain. For these, as the word passion implies, are pleasant and unpleasant experiences to which we are subjected; they are not acts on our part, but things done to us ; only the judgment and appreciation of art is an activity. Aesthetic experience is of the skin you love to touch, or the fruit you love to taste. " Disinterested æsthetic contemplation " is a contradiction in terms and a pure non-sense. Art is an intellectual, not a physical virtue ;

beauty has to do with knowledge and goodness, of which it is precisely the attractive aspect ; and since it is by its beauty that we are attracted to a work, its beauty is evidently a means to an end, and not itself the end of art ; the purpose of art is always one of effective communication. The man of action, then, will not be content to substitute the knowledge of what he likes for an understanding judgment ; he will not merely enjoy what he should use (those who merely enjoy we call 'æsthetes' rightly) ; it is not the æsthetic surfaces of works of art but the right reason or logic of the composition that will concern him. Now the composition of such works as we are exhibiting is not for æsthetic but for expressive reasons. The fundamental judgment is of the degree of the artist's success in giving clear expression to the theme of his work. In order to answer the question, Has the thing been well said ? it will evidently be necessary for us to know what it was that was to be said. It is for this reason that in every discussion of works of art we must begin with their subject matter.

We take account, in other words, of the *form* of the work. "Form" in the traditional philosophy does not mean tangible shape, but is synonymous with idea and even with soul ; the soul, for example, is called the form of the body.[1] If there be a real unity of form and matter such as we expect in a work of art, the shape of its body will express its form, which is that of the pattern in the artist's mind, to which pattern or image he moulds the material shape. The degree of his success in this imitative operation is the measure of the work's perfection. So God is said to have called his creation good because it conformed to the intelligible pattern according

[1] Accordingly, the following sentence (taken from the *Journal of Aesthetics*, I, p. 29), "Walter Pater here seems to be in the right when he maintains that it is the sensuous element of art that is essentially artistic, from which follows his thesis that music, the most formal of the arts, is also the measure of all the arts" propounds a shocking *non sequitur* and can only confuse the unhappy student.

to which he had worked ; it is in the same way that the human workman still speaks of " trueing " his work. The formality of a work is its beauty, its informality its ugliness. If it is uninformed it will be shapeless. Everything must be in good form.

In the same way *art* is nothing tangible. We cannot call a painting " art.'" As the words " artifact " and " artificial " imply, the thing made is a work *of* art, made *by* art, but not itself art ; the art remains in the artist and is the knowledge by which things are made. What is made according to the art is correct ; what one makes as one likes may very well be awkward. We must not confuse taste with judgment, or loveliness with beauty, for as Augustine says, some people like deformities.

Works of art are generally *ornamental* or in some way ornamented. The Docent will sometimes discuss the history of ornament. In doing so he will explain that all the words that mean ornament or decoration in the four languages with which we are chiefly concerned, and probably in all languages, originally meant equipment ; just as furnishing originally meant tables and chairs for use and not an interior decoration designed to keep up with the Joneses or to display our connoisseurship. We must not think of ornament as something added to an object which might have been ugly without it. The beauty of anything unadorned is not increased by ornament, but made more effective by it. Ornament is characterization ; ornaments are attributes. We are often told, and not quite incorrectly, that primitive ornament had a magical value ; it would be truer to say a metaphysical value, since it is generally by means of what we now call its decoration that a thing is ritually transformed and made to function spiritually as well as physically. The use of solar symbols in harness, for example, makes the steed the Sun in a likeness ; solar patterns are appropriate to buttons because the Sun

himself is the primordial fastening to which all things are attached by the thread of the Spirit ; the egg and dart pattern was originally what it still is in India, a lotus petal moulding symbolic of a solid foundation. It is only when the symbolic values of ornament have been lost, that decoration becomes a sophistry, irresponsible to the content of the work. For Socrates, the distinction of beauty from use is logical, but not real, not objective ; a thing can only be beautiful in the context for which it is designed.

Critics nowadays speak of an artist as *inspired* by external objects, or even by his material. This is a misuse of language that makes it impossible for the student to understand the earlier literature or art. " Inspiration " can never mean anything but the working of some spiritual force within you ; the word is properly defined by Webster as a " supernatural divine influence." The Docent, if a rationalist, may wish to deny the possibility of inspiration ; but he must not obscure the fact that from Homer onwards the word has been used always with one exact meaning, that of Dante, when he says that Love, that is to say the Holy Ghost, " inspires " him, and that he goes " setting the matter forth even as He dictates within me."

Nature, for example in the statement " Art imitates nature in her manner of operation," does not refer to any visible part of our environment ; and when Plato says " according to nature," he does not mean " as things behave," but as they should behave, not " sinning against nature." The traditional Nature is Mother Nature, that principle by which things are " natured," by which, for example, a horse is horsey and by which a man is human. Art is an imitation of the nature of things, not of their appearances.

In these ways we shall prepare our public to understand the pertinence of ancient works of art. If, on the

other hand, we ignore the evidence and decide that the appreciation of art is merely an æsthetic experience, we shall evidently arrange our exhibition to appeal to the public's sensibilities. This is to assume that the public must be taught to feel. But the view that the public is a hard-hearted animal is strangely at variance with the evidence afforded by the kind of art that the public chooses for itself, without the help of museums. For we perceive that this public already knows what it likes. It likes fine colours and sounds and whatever is spectacular or personal or anecdotal or that flatters its faith in progress. This public loves its comfort. If we believe that the appreciation of art is an æsthetic experience we shall give the public what it wants.

But it is not the function of a museum or of any educator to flatter and amuse the public. If the exhibition of works of art, like the reading of books, is to have a cultural value, i.e., if it is to nourish and make the best part of us grow, as plants are nourished and grow in suitable soils, it is to the understanding and not to fine feelings that an appeal must be made. In one respect the public is right ; it always wants to know what a work of art is " about." " About what," as Plato asked, " does the sophist make us so eloquent ? " Let us tell them what these works of art are about and not merely tell them things about these works of art. Let us tell them the painful truth, that most of these works of art are about God, whom we never mention in polite society. Let us admit that if we are to offer an education in agreement with the innermost nature and eloquence of the exhibits themselves, that this will not be an education in sensibility, but an education in philosophy, in Plato's and Aristotle's sense of the word, for whom it means ontology and theology and the map of life, and a wisdom to be applied to everyday matters. Let us recognize that nothing will have been accomplished

unless men's lives are affected and their values changed by what we have to show. Taking this point of view, we shall break down the social and economic distinction of fine from applied art ; we shall no longer divorce anthropology from art, but recognize that the anthropological approach to art is a much closer approach than the æsthetician's ; we shall no longer pretend that the content of the folk arts is anything but metaphysical. We shall teach our public to demand above all things lucidity in works of art.

For example, we shall place a painted Neolithic potsherd or Indian punch-marked coin side by side with a Mediæval representation of the Seven gifts of the Spirit, and make it clear by means of labels or Docents or both that the reason of all these compositions is to state the universal doctrine of the " Seven Rays of the Sun." We shall put together an Egyptian representation of the Sundoor guarded by the Sun himself and the figure of the Pantokrator in the oculus of a Byzantine dome, and explain that these doors by which one breaks out of the universe are the same as the hole in the roof by which an American Indian enters or leaves his *hogan*, the same as the hole in the centre of a Chinese *pi*, the same as the luffer of the Siberian Shaman's *yurt*, and the same as the foramen of the roof above the altar of Jupiter Terminus ; explaining that all these constructions are reminders of the Door-god, of One who could say " I am the door." Our study of the history of architecture will make it clear that " harmony " was first of all a carpenter's word meaning " joinery," and that it was inevitable, equally in the Greek and the Indian traditions that the Father and the Son should have been " carpenters," and show that this must have been a doctrine of Neolithic, or rather " Hylic," antiquity. We shall sharply distinguish the " visual education " that only tells us what things look like (leaving us to

react as we must) from the iconograph of things that are themselves invisible (but by which we can be guided how to *act*).

It may be that the understanding of the ancient works of art and of the conditions under which they were produced will undermine our loyalty to contemporary art and contemporary methods of manufacture. This will be the proof of our success as educators ; we must not shrink from the truth that all education implies revaluation. Whatever is made only to give pleasure is, as Plato put it, a toy, for the delectation of that part of us that passively submits to emotional storms ; whereas the education to be derived from works of art should be an education in the love of what is ordered and the dislike of what is disordered. We have proposed to educate the public to ask first of all these two questions of a work of art, Is it true ? or beautiful ? (whichever word you prefer) and what good use does it serve ? We shall hope to have demonstrated by our exhibition that the human value of anything made is determined by the coincidence in it of beauty and utility, significance and aptitude ; that artifacts of this sort can only be made by free and responsible workmen, free to consider only the good of the work to be done and individually responsible for its quality : and that the manufacture of " art " in studios coupled with an artless " manufacture " in factories represents a reduction of the standard of living to subhuman levels.

These are not personal opinions, but only the logical deductions of a lifetime spent in the handling of works of art, the observation of men at work, and the study of the universal philosophy of art from which philosophy our own " æsthetic " is only a temporally provincial aberration. It is for the museum militant to maintain with Plato that " we cannot give the name of art to anything irrational."

II

THE CHRISTIAN AND ORIENTAL, OR TRUE, PHILOSOPHY OF ART

Cum artifex . . . tum vir, Cicero, *Pro Quintio*, XXV. 78.

I HAVE called this lecture the "Christian and Oriental" philosophy of art because we are considering a catholic or universal doctrine, with which the humanistic philosophies of art can neither be compared nor reconciled, but only contrasted ; and "True" philosophy both because of its authority and because of its consistency. It will not be out of place to say that I believe what I have to expound : for the study of any subject can live only to the extent that the student himself stands or falls by the life of the subject studied ; the interdependence of faith and understanding[1] applying as much to the theory of art as to any other doctrine. In the text of what follows I shall not distinguish Christian from Oriental, nor cite authorities by chapter and verse : I have done this elsewhere, and am hardly afraid that anyone will imagine that I am propounding any views that I regard as my own except in the sense that I have made them my own. It is not the personal view of anyone that I shall try to explain, but that doctrine of art which is intrinsic to the Philosophia Perennis and can be recognized wherever it has not been forgotten that "culture" originates in work and not in play. If I use the language of Scholasticism rather than a Sanskrit vocabulary, it is because I am talking English, and must use that kind of English in which ideas can be clearly expressed.

Man's activity consists in either a making or a doing.

23

Both of these aspects of the active life depend for their correction upon the contemplative life. The making of things is governed by art, the doing of things by prudence.[2] An absolute distinction of art from prudence is made for purposes of logical understanding :[3] but while we make this distinction, we must not forget that the man is a whole man, and cannot be justified as such merely by what he makes ; the artist works " by art and *willingly*."[4] Even supposing that he avoids artistic sin, it is still essential to him as a man to have had a right will, and so to have avoided moral sin.[5] We cannot absolve the artist from this moral responsibility by laying it upon the patron, or only if the artist be in some way compelled ; for the artist is normally either his own patron, deciding what is to be made, or formally and freely consents to the will of the patron, which becomes his own as soon as the commission has been accepted, after which the artist is only concerned with the good of the work to be done[6] : if any other motive affects him in his work he has no longer any proper place in the social order. Manufacture is for use and not for profit. The artist is not a special kind of man, but every man who is not an artist in some field, every man without a vocation, is an idler. The kind of artist that a man should be, carpenter, painter, lawyer, farmer or priest, is determined by his own nature, in other words by his nativity. The only man who has a right to abstain from all constructive activities is the monk who has also surrendered all those uses that depend on things that can be made and is no longer a member of society. No man has a right to any social status who is not an artist.

We are thus introduced at the outset to the problem of the use of art and the worth of the artist to a serious society. This use is in general the good of man, the good of society, and in particular the occasional good

24

of an individual requirement. All of these goods correspond to the desires of men : so that what is actually made in a given society is a key to the governing conception of the purpose of life in that society, which can be judged by its works in that sense, and better than in any other way. There can be no doubt about the purpose of art in a traditional society : when it has been decided that such and such a thing should be made, it is *by art* that it can be properly made. There can be no good use without art[7] : that is, no good use if things are not properly made. The artist is producing a utility, something to be used. Mere pleasure is not a use from this point of view. An illustration can be given in our taste for Shaker or other simple furniture, or for Chinese bronzes or other abstract arts of exotic origin, which are not foods but sauces to our palate. Our " æsthetic " appreciation, essentially sentimental because it is just what the word " æsthetic " means, a kind of feeling rather than an understanding, has little or nothing to do with their *raison d'être*. If they please our taste and are fashionable, this only means that we have over-eaten of other foods, not that we are such as those who made these things and made " good use " of them. To " enjoy " what does not correspond to any vital needs of our own and what we have not verified in our own life can only be described as an indulgence. It is luxurious to make mantelpiece ornaments of the artefacts of what we term uncivilised or superstitious peoples, whose culture we think of as much inferior to our own, and which our touch has destroyed : the attitude, however ignorant, of those who used to call these things " abominations " and " beastly devices of the heathen," was a much healthier one. It is the same if we read the scriptures of any tradition, or authors such as Dante or Ashvaghosha who tell us frankly that they wrote with other than " æsthetic " ends in view ; or if we

listen to sacrificial music for the ears' sake only. We have a right to be pleased by these things only through our understanding use of them. We have goods enough of our own " perceptible to the senses " : if the nature of our civilisation be such that we lack a sufficiency of " intelligible goods," we had better remake ourselves than divert the intelligible goods of others to the multi-plication of our own æsthetic satisfactions.

In the philosophy that we are considering, only the contemplative and active lives are reckoned human. The life of pleasure only, one of which the end is pleasure, is subhuman ; every animal " knows what it likes," and seeks for it. This is not an exclusion of pleasure from life as if pleasure were wrong in itself , it is an exclusion of the pursuit of pleasure thought of as a " diversion," and apart from " life." It is in life itself, in " proper operation," that pleasure arises naturally, and this very pleasure is said to " perfect the operation " itself.[8] In the same way in the case of the pleasures of use or the understanding of use.

We need hardly say that from the traditional point of view there could hardly be found a stronger condemna-tion of the present social order than in the fact that the man at work is no longer doing what he likes best, but rather what he must, and in the general belief that a man can only be really happy when he " gets away " and is at play. For even if we mean by " happy " to enjoy the " higher things of life," it is a cruel error to pretend that this can be done at leisure if it has not been done at work. For " the man devoted to his own vocation finds perfection. . . . That man whose prayer and praise of God are in the doing of his own work perfects himself."[9] It is this way of life that our civilisa-tion denies to the vast majority of men, and in this respect that it is notably inferior to even the most primitive or savage societies with which it can be contrasted.

Manufacture, the practise of an art, is thus not only the production of utilities but in the highest possible sense the education of men. It can never be, unless for the sentimentalist who lives for pleasure, an " art for art's sake," that is to say a production of " fine " or useless objects only that we may be delighted by " fine colours and sounds " ; neither can we speak of our traditional art as a " decorative " art, for to think of decoration as its essence would be the same as to think of millinery as the essence of costume or of upholstery as the essence of furniture. The greater part of our boasted " love of art " is nothing but the enjoyment of comfortable feelings. One had better be an artist than go about " loving art " : just as one had better be a botanist than go about " loving the pines."

In our traditional view of art, in folk-art, Christian and Oriental art, there is no essential distinction of a fine and useless art from a utilitarian craftsmanship.[10] There is no distinction in principle of orator from carpenter,[11] but only a distinction of things well and truly made from things not so made and of what is beautiful from what is ugly in terms of formality and informality. But, you may object, do not some things serve the uses of the spirit or intellect, and others those of the body ; is not a symphony nobler than a bomb, an icon than a fireplace ? Let us first of all beware of confusing art with ethics. " Noble " is an ethical value, and pertains to the a priori censorship of what ought or ought not to be made at all. The judgment of works of art from this point of view is not merely legitimate, but essential to a good life and the welfare of humanity. But it is not a judgment of the work of art as such. The bomb, for example, is only bad as a work of art if it fails to destroy and kill to the required extent. The distinction of artistic from moral sin which is so sharply drawn in Christian philosophy can be recognized again in Confucius, who speaks

of a Succession Dance as being " at the same time perfect beauty and perfect goodness," and of the War Dance as being " perfect beauty but not perfect goodness."[12] It will be obvious that there can be no moral judgment of art itself, since it is not an act but a kind of knowledge or power by which things can be well made, whether for good or evil use : the art by which utilities are produced cannot be judged morally, because it is not a kind of willing but a kind of knowing.

Beauty in this philosophy is the attractive power of perfection.[13] There are perfections or beauties of different kinds of things or in different contexts, but we cannot arrange these beauties in a hierarchy, as we can the things themselves : we can no more say that a cathedral as such is " better " than a barn as such than we can say that a rose as such is " better " than a skunk cabbage as such ; each is beautiful to the extent that it is what it purports to be, and in the same proportion good.[14] To say that a perfect cathedral is a greater work of art than a perfect barn is either to assume that there can be degrees of perfection, or to assume that the artist who made the barn was really trying to make a cathedral. We see that this is absurd ; and yet it is just in this way that whoever believes that art " progresses " contrasts the most primitive with the most advanced (or decadent) styles of art, as though the primitive had been trying to do what we try to do, and had drawn like that while really trying to draw as we draw ; and that is to impute artistic sin to the primitive (any sin being defined as a departure from the order to the end). So far from this, the only test of excellence in a work of art is the measure of the artist's actual success in making what was intended.

One of the most important implications of this position is that beauty is objective, residing in the artefact and not in the spectator, who may or may not be qualified to recognize it.[15] The work of art is good of its kind, or

not good at all ; its excellence is as independent of our reactions to its æsthetic surfaces as it is of our moral reaction to its thesis. Just as the artist conceives the form of the thing to be made only after he has consented to the patron's will, so we, if we are to judge as the artist could, must already have consented to the existence of the object before we can be free to compare its actual shape with its prototype in the artist. We must not condescend to " primitive " works by saying " That was before they knew anything about anatomy, or perspective," or call their work " unnatural " because of its formality : we must have learnt that these primitives did not feel our kind of interest in anatomy, nor intend to tell us what things are like ; we must have learnt that it is because they had something definite to say that their art is more abstract, more intellectual, and less than our own a matter of mere reminiscence or emotion. If the mediæval artist's constructions corresponded to a certain way of thinking, it is certain that we cannot understand them except to the extent that we can identify ourselves with this way of thinking. " The greater the ignorance of modern times, the deeper grows the darkness of the Middle Ages."[16] The Middle Ages and the East are mysterious to us only because we know, not what to think, but what we like to think. As humanists and individualists it flatters us to think that art is an expression of personal feelings and sentiments, preference and free choice, unfettered by the sciences of mathematics and cosmology. But mediæval art was not like ours "free" to ignore truth. For them, *Ars sine scientia nihil* :[17] by " science," we mean of course, the reference of all particulars to unifying principles, not the " laws " of statistical prediction.

The perfection of the object is something of which the critic cannot judge, its beauty something that he cannot feel, if he has not like the original artist made himself

such as the thing itself should be ; it is in this way that
" criticism is reproduction," and " judgment the per-
fection of art." The " appreciation of art " must not
be confused with a psycho-analysis of our likes and dis-
likes, dignified by the name of " æsthetic reactions " :
" æsthetic pathology is an excrescence upon a genuine
interest in art which seems to be peculiar to civilised
peoples."[18] The study of art, if it is to have any cultural
value will demand two far more difficult operations than
this, in the first place an understanding and acceptance
of the whole point of view from which the necessity for
the work arose, and in the second place a bringing to life
in ourselves of the form in which the artist conceived the
work and by which he judged it. The student of art,
if he is to do more than accumulate facts, must also sacri-
fice himself : the wider the scope of his study in time
and space, the more must he cease to be a provincial,
the more he must universalize himself, whatever may be
his own temperament and training. He must assimilate
whole cultures that seem strange to him, and must also
be able to elevate his own levels of reference from those
of observation to that of the vision of ideal forms. He
must rather love than be curious about the subject of his
study. It is just because so much is demanded that the
study of " art " can have a cultural value, that is to say
may become a means of growth. How often our college
courses require of the student much less than this !

A need, or " indigence " as Plato calls it, is thus the
first cause of the production of a work of art. We spoke
of spiritual and physical needs, and said that works of
art could *not* be classified accordingly. If this is difficult
for us to admit, it is because we have forgotten what we
are, what " man " in this philosophy denotes, a spiritual
as well as a psychophysical being. We are therefore
well contented with a functional art, good of its kind
insofar as goodness does not interfere with profitable

saleability, and can hardly understand how things to be used can also have a meaning. It is true that what we have come to understand by " man," viz., " the reasoning and mortal animal,"[19] can live by " bread alone," and that bread alone, make no mistake about it, is therefore a good ; to function is the very least that can be expected of any work of art. " Bread alone " is the same thing as a " merely functional art." But when it is said that man does not live by bread alone but " by every word that proceedeth out of the mouth of God,"[20] it is the whole man that is meant. The " words of God " are precisely those ideas and principles that can be expressed whether verbally or visually by art ; the words or visual forms in which they are expressed are not merely sensible but also significant. To separate as we do the functional from the significant art, applied from a so-called fine art, is to require of the vast majority of men to live by the merely functional art, a " bread alone " that is nothing but the " husks that the swine did eat." The insincerity and inconsistency of the whole position is to be seen in the fact that we do not expect of the " significant " art that it be significant *of* anything, nor from the " fine " art anything but an " æsthetic " pleasure ; if the artist himself declares that his work is charged with meaning and exists for the sake of this meaning, we call it an irrelevance, but decide that he may have been an artist in spite of it.[21] In other words, if the merely functional arts are the husks, the fine arts are the tinsel of life, and art for us has no significance whatever.

Primitive man, despite the pressure of his struggle for existence, knew nothing of such merely functional arts. The whole man is naturally a metaphysician, and only later on a philosopher and psychologist, a systematist. His reasoning is by analogy, or in other words by means of an " adequate symbolism." As a person rather than an animal he knows immortal through mortal things.[22]

That the " invisible things of God " (that is to say, the
ideas or eternal reasons of things, by which we know
what they ought to be like) are to be seen in " the things
that are made "[23] applied for him not only to the things
that God had made but to those that he made himself.
He could not have thought of meaning as something
that might or might not be added to useful objects
at will. Primitive man made no real distinction of
sacred from secular : his weapons, clothing, vehicles
and house were all of them imitations of divine prototypes,
and were to him even more what they meant than what
they were in themselves ; he made them this " more "
by incantation and by rites.[24] Thus he fought with
thunderbolts, put on celestial garments, rode in a chariot
of fire, saw in his roof the starry sky, and in himself
more than " this man " So-and-so. All these things
belonged to the " Lesser Mysteries " of the crafts, and
to the knowledge of " Companions." Nothing of it
remains to us but the transformation of the bread in
sacrificial rites, and in the reference to its prototype of
the honour paid to an icon.

The Indian actor prepares for his performance by
prayer. The Indian architect is often spoken of as
visiting heaven and there making notes of the prevailing
forms of architecture, which he imitates here below.
All traditional architecture, in fact, follows a cosmic
pattern.[25] Those who think of their house as only a
" machine to live in " should judge their point of view
by that of Neolithic man, who also lived in a house,
but a house that embodied a cosmology. We are more
than sufficiently provided with overheating systems :
we should have found his house uncomfortable ; but
let us not forget that he identified the column of smoke
that rose from his hearth to disappear from view through a
hole in the roof with the Axis of the Universe, saw in this
luffer an image of the Heavenly Door, and in his hearth

the Navel of the Earth, formulæ that we at the present day are hardly capable of understanding ; we, for whom "such knowledge as is not empirical is meaningless."[26] Most of the things that Plato called "ideas" are only "superstitions" to us.

To have seen in his artefacts nothing but the things themselves, and in the myth a mere anecdote would have been a mortal sin, for this would have been the same as to see in oneself nothing but the "reasoning and mortal animal," to recognize only "this man," and never the "form of humanity." It is just insofar as we do now see only the things as they are in themselves, and only ourselves as we are in ourselves, that we have killed the metaphysical man and shut ourselves up in the dismal cave of functional and economic determinism. Do you begin to see now what I meant by saying that works of art consistent with the Philosophia Perennis cannot be divided into the categories of the utilitarian and the spiritual, but pertain to both worlds, functional and significant, physical and metaphysical ?[27]

II

The artist has now accepted his commission and is expected to practise his art. It is by this art that he knows both what the thing should be like, and how to impress this form upon the available material, so that it may be informed with what is actually alive in himself. His operation will be twofold, "free" and servile," theoretical and operative, inventive and imitative. It is in terms of the freely invented formal cause that we can best explain how the pattern of the thing to be made or arranged, this essay or this house for example, is known. It is this cause by which the actual shape of the thing can best be understood ; because "similitude is with respect to the form"[28] of the thing to be made, and

not with respect to the shape or appearance of some other
and already existing thing : so that in saying " imitative "
we are by no means saying " naturalistic." " Art
imitates nature in her manner of operation,"[29] that is to
say God in his manner of creation, in which he does not
repeat himself or exhibit deceptive illusions in which the
species of things are confused.

How is the form of the thing to be made evoked ?
This is the kernel of our doctrine, and the answer can
be made in a great many different ways. The art of
God is the Son " through whom all things are made " ;[30]
in the same way the art in the human artist is his child
through which some one thing is to be made. The
intuition-expression of an imitable form is an intellectual
conception born of the artist's wisdom, just as the eternal
reasons are born of the Eternal Wisdom.[31] The image
arises naturally in his spirit, not by way of an aimless
inspiration, but in purposeful and vital operation, " by a
word *conceived* in intellect."[32] It is this filial image,
and not a retinal reflection or the memory of a retinal
reflection, that he imitates in the material, just as at the
creation of the world " God's will beheld that beauteous
world and imitated it,"[33] that is to say impressed on
primary matter a " world-picture " already " painted by
the spirit on the canvas of the spirit."[34] All things are
to be seen in this eternal mirror better than in any other
way :[35] for there the artist's models are all alive and
more alive than those that are posed when we are taught
in schools of art to draw " from life." If shapes of natural
origin often enter into the artist's compositions, this does
not mean that they pertain to his art, but they are the
material in which the form is clothed ; just as the poet
uses sounds, which are not his thesis, but only means.
The artist's spirals are the forms of life, and not only
of this or that life ; the form of the crozier was not
suggested by that of a fern frond. The superficial

resemblances of art to " nature " are accidental ; and when they are deliberately sought, the art is already in its anecdotage. It is not by the looks of existing things, but as Augustine says, by their ideas, that we know what we proposed to make should be like.[36] He who does not see more vividly and clearly than this perishing mortal eye can see, does not see creatively at all ;[37] " The city can never otherwise be happy unless it is drawn by those painters who follow a divine original."[38]

What do we mean by " invention " ? The entertainment of ideas ; the intuition of things as they are on higher than empirical levels of reference. We must digress to explain that in using the terms intuition and expression as the equivalents of conception or generation, we are not thinking either of Bergson or of Croce. By " intuition " we mean with Augustine an intellection extending beyond the range of dialectic to that of the eternal reasons[39]—a contemplation, therefore, rather than a thinking : by " expression " we mean with Bonaventura a begotten rather than a calculated likeness.[40]

It may be asked, How can the artist's primary act of imagination be spoken of as " free " if in fact he is working to some formula, specification or iconographic prescription, or even drawing from nature ? If in fact a man is blindly copying a shape defined in words or already visibly existing, he is not a free agent, but only performing a servile operation. This is the case in quantitative production ; here the craftsman's work, however skilful, can be called mechanical rather than artistic, and it is only in this sense that the phrase " mere craftsmanship " acquired a meaning. It would be the same with the performance of any rite, [1] to the extent that performance becomes a habit, unenlivened by any recollection. The mechanical product may still be a work of art : but the art was not the workman's, nor the workman an artist, but a hireling ; and this is one of the

many ways in which an "Industry without art is brutality."

The artist's theoretical or imaginative act is said to be "free" because it is *not* assumed or admitted that he is blindly copying any model extrinsic to himself, but expressing himself, even in adhering to a prescription or responding to requirements that may remain essentially the same for millennia. It is true that to be properly expressed a thing must proceed from within, moved by its form :[42] and yet it is not true that in practising an art that has "fixed ends and ascertained means of operation"[43] the artist's freedom is denied ; it is only the academician and the hireling whose work is under constraint. It is true that if the artist has not conformed *himself* to the pattern of the thing to be made he has not really known it and cannot work originally.[44] But if he has thus conformed himself he will be in fact expressing *himself* in bringing it forth.[45] Not indeed expressing his "personality," himself as "this man" So-and-So, but himself *sub specie æternitatis*, and apart from individual idiosyncracy. The idea of the thing to be made is brought to life in him, and it will be from this supra-individual life of the artist himself that the vitality of the finished work will be derived.[46] "It is not the tongue, but our very life that sings the new song."[47] In this way too the human operation reflects the manner of operation *in divinis* : "All things that were made were life in Him."[48]

"Through the mouth of Hermes the divine Eros began to speak."[49] We must not conclude from the form of the words that the artist is a passive instrument, like a stenographer. "He" is much rather actively and consciously making use of "himself" as an instrument. Body and mind are not the man, but only his instrument and vehicle. The man is passive only when he identifies himself with the psychophysical ego letting it take him

where it will : but in act when he directs it. Inspiration and aspiration are not exclusive alternatives, but one and the same ; because the spirit to which both words refer cannot work in the man except to the extent that *he* is " in the spirit." It is only when the form of the thing to be made has been known that the artist returns to " himself," performing the servile operation with good will, a will directed solely to the good of the thing to be made. He is willing to make " what was shown him upon the Mount." The man incapable of contemplation cannot be an artist, out only a skilful workman ; it is demanded of the artist to be both a contemplative and a good workman. Best of all if, like the angels, he need not in his activity " lose the delights of inward contemplation."

What is implied by contemplation is to raise our level of reference from the empirical to the ideal, from observation to vision, from any auditory sensation to audition ; the imager (or worshipper, for no distinction can be made here) " taking ideal form under the action of the vision, while remaining only potentially ' himself '."[50] " I am one," says Dante, accounting for his *dolce stil nuovo*, " who when Love inspires me take note, and go setting it forth in such wise as He dictates within me."[51] " Lo, make all things in accordance with the pattern that was shown thee on the mount."[52] " It is in imitation of angelic works of art that any work of art is wrought here " :[53] the " crafts such as building and carpentry take their principles from that realm and from the thinking there."[54] It is in agreement with these traditional dicta that Blake equated with Christianity itself " the divine arts of imagination " and asked " Is the Holy Ghost any other than an intellectual fountain ? " and that Emerson said, " The intellect searches out the absolute order of things as they stand in the mind of God, and without the colours of affection." Where we see

" genius " as a peculiarly developed " personality " to be exploited, traditional philosophy sees the immanent Spirit, beside which the individual personality is relatively nil : " Thou madest," as Augustine says ," that *ingenium* whereby the artificer may take his art, and may see within what he has to do without."[55] It is the light of this Spirit that becomes " the light of a mechanical art." What Augustine calls *ingenium* corresponds to Philo's Hegemon, the Sanskrit " Inner Controller," and to what is called in mediæval theology the Synteresis, the immanent Spirit thought of equally as an artistic, moral and speculative conscience, both as we use the word and in its older sense of " consciousness." Augustine's *ingenium* corresponds to Greek *daimon*, but not to what we mean to-day by " genius." No man, considered as So-and-so, can *be* a genius : but all men *have* a genius, to be served or disobeyed at their own peril. There can be no property in ideas, because these are gifts of the Spirit, and not to be confused with talents : ideas are never made, but can only be " invented," that is " found," and entertained. No matter how many times they may already have been " applied " by others, whoever conforms himself to an idea and so makes it his own, will be working originally, but not so if he is expressing only his own ideals or opinions.

To " think for oneself " is always to think of oneself ; what is called " freethought " is therefore the natural expression of a humanistic philosophy. We are at the mercy of our thoughts and corresponding desires. Free thought is a passion ; it is much rather the thoughts than ourselves that are free. We cannot too much emphasize that contemplation is not a passion but an act : and that where modern psychology sees in " inspiration " the uprush of an instinctive and *sub*conscious will, the orthodox philosophy sees an elevation of the artist's being to *super*conscious and *supra*individual levels.

Where the psychologist invokes a demon, the metaphysician invokes a dæmon : what is for the one the "libido" is for the other "the divine Eros."[56]

There is also a sense in which the man as an individual "expresses himself," whether he will or no. This is inevitable, only because nothing can be known or done except in accordance with the mode of the knower. So the man himself, as he is in himself, appears in style and handling, and can be recognized accordingly. The uses and significance of works of art may remain the same for millennia, and yet we can often date and place a work at first glance. Human idiosyncrasy is thus the explanation of style and of stylistic sequences : "style is the man." Styles are the basis of our histories of art, which are written like other histories to flatter our human vanity. But the artist whom we have in view is innocent of history and unaware of the existence of stylistic sequences. Styles are the accident and by no means the essence of art ; the free man is not trying to express himself, but that which was to be expressed. Our conception of art as essentially the expression of a personality, our whole view of genius, our impertinent curiosities about the artist's private life, all these things are the products of a perverted individualism and prevent our understanding of the nature of mediæval and oriental art. The modern mania for attribution is the expression of Renaissance conceit and nineteenth century humanism ; it has nothing to do with the nature of mediæval art, and becomes a pathetic fallacy when applied to it.[57]

In all respects the traditional artist devotes himself to the good of the work to be done.[57A] The operation is a rite, the celebrant neither intentionally nor even consciously expressing himself. It is by no accident of time, but in accordance with a governing concept of the meaning of life, of which the goal is implied in St. Paul's *Vivo autem jam non ego*, that works of traditional art,

whether Christian, Oriental or folk art, are hardly ever signed : the artist is anonymous, or if a name has survived, we know little or nothing of the man. This is true as much for literary as for plastic artefacts. In traditional arts it is never Who said ? but only What was said ? that concerns us : for " all that is true, by whomsover it has been said, has its origin in the Spirit."[58]

So the first sane questions that can be asked about a work of art are, What was it for ? and What does it mean ? We have seen already that whatever, and however humble, the functional purpose of the work of art may have been, it had always a spiritual meaning, by no means an arbitrary meaning, but one that the function tself expresses adequately by analogy. Function and meaning cannot be forced apart ; the meaning of the work of art is its intrinsic form as much as the soul is the form of the body. Meaning is even historically prior to utilitarian application. Forms such as that of the dome, arch and circle have not been " evolved," but only applied : the circle can no more have been suggested by the wheel than a myth by a mimetic rite. The ontology of useful inventions parallels that of the world : in both " creations " the Sun is the single form of many different things ; that this is actually so in the case of human production by art will be realised by everyone who is sufficiently familiar with the solar significance of almost every known type of circular or annular artefact or part of an artefact. I will only cite by way of example the eye of a needle, and remark that there is a metaphysics of embroidery and weaving, for a detailed exposition of which a whole volume might be required. It is in the same way by no accident that the Crusader's sword was also a cross, at once the means of physical and symbol of spiritual victory. There is no traditional game or any form of athletics, nor any kind of fairy-tale properly to be so called (excepting, that is to say, those which merely

reflect the fancies of individual literateurs, a purely modern phenomenon) nor any sort of traditional jugglery, that is not at the same time that it is an entertainment, the embodiment of a metaphysical doctrine. The meaning is literally the " spirit " of the performance or the anecdote. Iconography, in other words, is art : that art by which the actual forms of things are determined ; and the final problem of research in the field of art is to understand the iconographic form of whatever composition it may be that we are studying. It is only when we have understood the *raisons d'etre* of iconography that we can be said to have gone back to first principles ; and that is what we mean by the " Reduction of Art to Theology."[59] The student understands the logic of the composition ; the illiterate only its æsthetic value.[60]

The anonymity of the artist belongs to a type of culture dominated by the longing to be liberated from oneself. All the force of this philosophy is directed against the delusion " I am the doer." " I " am not in fact the doer, but the instrument ; human individuality is not an end but only a means. The supreme achievement of individual consciousness is to lose or find (both words mean the same) itself in what is both its first beginning and its last end : " Whoever would save his *psyche*, let him lose it."[61] All that is required of the instrument is efficiency and obedience ; it is not for the subject to aspire to the throne ; the constitution of man is not a democracy, but the hierarchy of body, soul and spirit. Is it for the Christian to consider any work " his own," when even Christ has said that " I do nothing of myself " ?[62] or for the Hindu, when Krishna has said that " The Comprehensor cannot form the concept ' I am the doer' " ?[63] or the Buddhist, for whom it has been said that " To wish that it may be made known that ' I was the author ' is the thought of a man not yet adult " ?[64] It hardly occurred to the individual artist to

sign his works, unless for practical purposes of distinction ; and we find the same conditions prevailing in the scarcely yet defunct community of the Shakers, who made perfection of workmanship a part of their religion, but made it a rule that works should not be signed.[65] It is under such conditions that a really living art, unlike what Plato calls the arts of flattery, flourishes ; and where the artist exploits his own personality and becomes an exhibitionist that art declines.

There is another aspect of the question that has to do with the patron rather than the artist ; this too must be understood, if we are not to mistake the intentions of traditional art. It will have been observed that in traditional arts, the effigy of an individual, for whatever purpose it may have been made, is very rarely a likeness in the sense that we conceive a likeness, but much rather the representation of a type.[66] The man is represented by his function rather than by his appearance ; the effigy is of the king, the soldier, the merchant or the smith, rather than of So-and-so. The ultimate reasons for this have nothing to do with any technical inabilities or lack of the power of observation in the artist, but are hard to explain to ourselves whose pre-occupations are so different and whose faith in the eternal values of " personality " is so naive ; hard to explain to ourselves, who shrink from the saying that a man must " hate " himself " if he would be My disciple."[67] The whole position is bound up with a traditional view that also finds expression in the doctrine of the hereditary transmission of character and function, because of which the man can die in peace, knowing that his work will be carried on by another representative. As So-and-so, the man is reborn in his descendants, each of whom occupies in turn what was much rather an office than a person. For in what we call personality, tradition sees only a temporal function " which you hold in lease." The very person

of the king, surviving death, may be manifested in some way in some other ensemble of possibilities than these ; but the royal personality descends from generation to generation, by hereditary and ritual delegation ; and so we say, The king is dead, long live the king. It is the same if the man has been a merchant or craftsman ; if the son to whom his personality has been transmitted is not also, for example, a blacksmith, the blacksmith of a given community, the family line is at an end ; and if personal functions are not in this way transmitted from generation to generation, the social order itself has come to an end, and chaos supervenes.

We find accordingly that if an ancestral image or tomb effigy is to be set up for reasons bound up with what is rather loosely called " ancestor worship," this image has two peculiarities, (1) it is identified as the image of the deceased by the insignia and costume of his vocation and the inscription of his name, and (2) for the rest, it is an individually indeterminate type, or what is called an " ideal " likeness. In this way both selves of the man are represented ; the one that is to be inherited, and that which corresponds to an intrinsic and regenerated form that he should have built up for himself in the course of life itself, considered as a sacrificial operation terminating at death. The whole purpose of life has been that this man should realise himself in this other and essential form, in which alone the form of divinity can be thought of as adequately reflected. As St. Augustine expresses it, " *This* likeness begins now to be formed again in us."[68] It is not surprising that even in life a man would rather be represented thus, not as he is, but as he ought to be, impassibly superior to the accidents of temporal manifestation. It is characteristic of ancestral images in many parts of the East, that they cannot be recognized, except by their legends, as the portraits of individuals ; there is nothing else to

distinguish them from the form of the divinity to whom the spirit had been returned when the man " gave up the ghost " ; almost in the same way an angelic serenity and the absence of human imperfection, and of the signs of age, are characteristic of the Christian effigy before the thirteenth century, when the study of death-masks came back into fashion and modern portraiture was born in the charnel house. The traditional image is of the man as he would be at the Resurrection, in an ageless body of glory, not as he was accidentally : "I would go down unto Annihilation and Eternal Death, lest the Last Judgment come and find me Unannihilate, and I be seiz'd and giv'n into the hands of my own Selfhood." Let us not forget that it is only the intellectual virtues, and by no means our individual affections, that are thought of as surviving death.

The same holds good for the heroes of epic and romance ; for modern criticism, these are "unreal types," and there is no " psychological analysis." We ought to have realised that if this is not a humanistic art, this may have been its essential virtue. We ought to have known that this was a typal art by right of long inheritance ; the romance is still essentially an epic, the epic essentially a myth ; and that it is just because the hero exhibits universal qualities, without individual peculiarity or limitations, that he can be a pattern imitable by every man alike in accordance with his own possibilities whatever these may be. In the last analysis the hero is always God, whose only idiosyncracy is being, and to whom it would be absurd to attribute individual characteristics. It is only when the artist, whatever his subject may be, is chiefly concerned to exhibit himself, and when we descend to the level of the psychological novel, that the study and analysis of individuality acquires an importance. Then only portraiture in our sense takes the place of what was once an iconographic portrayal.

All these things apply only so much the more if we are to consider the deliberate portrayal of a divinity, the fundamental thesis of all traditional arts. An adequate knowledge of theology and cosmology is then indispensible to an understanding of the history of art, insofar as the actual shapes and structures of works of art are determined by their real content. Christian art, for example, begins with the representation of deity by abstract symbols, which may be geometrical, vegetable or theriomorphic, and are devoid of any sentimental appeal whatever. An anthropomorphic symbol follows, but this is still a form and not a figuration ; not made as though to function biologically or as if to illustrate a text book of anatomy or of dramatic expression. Still later, the form is sentimentalised ; the features of the crucified are made to exhibit human suffering, the type is completely humanised, and where we began with the shape of humanity as an analogical representation of the idea of God, we end with the portrait of the artist's mistress posing as the Madonna and the representation of an all-too-human baby; the Christ is no longer a man-God, but the sort of man that we can approve of. With what extraordinary prescience St. Thomas Aquinas commends the use of the lower rather than the nobler forms of existence as divine symbols, " especially for those who can think of nothing nobler than bodies " [69]

The course of art reflects the course of thought. The artist, asserting a specious liberty, expresses himself ; our age commends the man who thinks for himself, and therefore of himself. We can see in the hero only an imperfectly remembered historical figure, around which there have gathered mythical and miraculous accretions ; the hero's manhood interests us more than his divinity, and this applies as much to our conception of Christ or Krishna or Buddha as it does to our conceptions of Cuchullain or Sigurd or Gilgamesh. We treat the

mythical elements of the story, which are its essence, as its accidents, and substitute anecdote for meaning. The secularisation of art and the rationalisation of religion are inseparably connected, however unaware of it we may be. It follows that for any man who can still believe in the eternal birth of any avatar ("Before Abraham was, I am") the content of works of art cannot be a matter of indifference ; the artistic humanisation of the Son or of the Mother of God is as much a denial of Christian truth as any form of verbal rationalism or other heretical position. The vulgarity of humanism appears nakedly and unashamed in all euhemerism.

It is by no accident that it should have been discovered only comparatively recently that art is essentially an "æsthetic" activity. No real distinction can be drawn between æsthetic and materialistic ; *aisthesis* being sensation, and matter what can be sensed. So we regard the lack of interest in anatomy as a defect of art, the absence of psychological analysis as evidence of undeveloped character ; we deprecate the representation of the Bambino as a little man rather than as a child, and think of the frontality of the imagery as due to an inability to realise the three-dimensional mass of existing things ; in place of the abstract light that corresponds to the gnomic aorists of the legend itself we demand the cast shadows that belong to momentary effects. We speak of a want of scientific perspective, forgetting that perspective in art is a kind of visual syntax and only a means to an end. We forget that while our perspective serves the purposes of representation in which we are primarily interested, there are other perspectives that are more intelligible and better adapted to the communicative purposes of the traditional arts.

In deprecating the secularisation of art we are not confusing religion with art, but seeking to understand the content of art at different times with a view to un-

biassed judgment. In speaking of the decadence of art, it is really the decadence of man from intellectual to sentimental interests that we mean. For the artist's skill may remain the same throughout : he is able to do what he intends. It is the mental image to which he works that changes : that " art has fixed ends " is no longer true as soon as we know what we like instead of liking what we know. Our point is that without an understanding of the change, the integrity of even a supposedly objective historical study is destroyed ; we judge the traditional works, not by their actual accomplishment, but by our own intentions, and so inevitably come to believe in a progress of art, as we do in the progress of man.

Ignorant of the traditional philosophy and of its formulæ we often think of the artist as having been trying to do just what he may have been consciously avoiding. For example, if Damascene says that Christ from the moment of his conception possessed a " rational and intellectual soul,"[71] if as St. Thomas Aquinas says " his body was perfectly formed and assumed in the first instant,"[72] if the Buddha is said to have spoken in the womb, and to have taken seven strides at birth, from one end to the other of the universe, could the artist have intended to represent either of the newborn children as a puling infant ? If we are disturbed by what we call the " vacancy " of a Buddha's expression, ought we not to bear in mind that he is thought of as the Eye in the World, the impassible spectator of things as they really are, and that it would have been impertinent to have given him features moulded by human curiosity or passion ? If it was an artistic canon that veins and bones should not be made apparent, can we blame the Indian artist as an artist for not displaying such a knowledge of anatomy as might have evoked *our* admiration ? If we know from authoritative literary sources that the

lotus on which the Buddha sits or stands is not a botanical specimen, but the universal ground of existence inflorescent in the waters of its indefinite possibilities, how inappropriate it would have been to represent him in the solid flesh precariously balanced on the surface of a real and fragile flower ! The same considerations will apply to all our reading of mythology and fairy tale, and to all our judgments of primitive, savage or folk art : the anthropologist whose interest is in a culture is a better historian of such arts than is the critic whose only interest is in the æsthetic surfaces of the artefacts themselves.

In the traditional philosophy, as we cannot too often repeat, " art has to do with cognition " ;[73] beauty is the attractive power of a perfect expression. This we can only judge and only really enjoy as an " intelligible good, which is the good of reason "[74] if we have really known what it was that was to be expressed. If sophistry be " ornament more than is appropriate to the thesis of the work,"[75] can we judge of what is or is not sophistry if we ourselves remain indifferent to this content ? Evidently not. One might as well attempt the study of Christian or Buddhist art without a knowledge of the corresponding philosophies as attempt the study of a mathematical papyrus without the knowledge of mathematics.

III

Let us conclude with a discussion of the problems of voluntary poverty and of iconoclasm. In cultures moulded by the traditional philosophy we find that two contrasting positions are maintained, either at any one time or alternately : the work of art, both as a utility and in its significance is on the one hand a good, and on the other an evil.

The ideal of voluntary poverty, which rejects utilities,

can be readily understood. It is easy to see that an indefinite multiplication of utilities, the means of life, may end in an identification of culture with comfort, and the substitution of means for ends ; to multiply wants is to multiply man's servitude to his own machinery. I do not say that this has not already taken place. On the other hand, the man is most self-sufficient, auto-chthonous and free who is least dependent upon possessions. We all recognize to some extent the value of living simply. But the question of possessions is a matter relative to the individual's vocation ; the workman needs his tools and the soldier his weapons, but the contemplative is the nearer to his goal the fewer his needs. It was not until after the Fall that Adam and Eve had occasion to practise the tailor's art : they had no images of a God with whom they daily conversed. The angels, also, " have fewer ideas and use less means than men."[76] Possessions are a necessity to the extent that we can use them ; it is altogether legitimate to enjoy what we do use, but equally inordinate to enjoy what we cannot use or to use what cannot be enjoyed. All possessions not at the same time beautiful and useful are an affront to human dignity. Ours is perhaps the first society to find it natural that some things should be beautiful and others useful. To be voluntarily poor is to have rejected what we cannot both admire and use ; this definition can be applied alike to the case of the millionaire and to that of the monk.

The reference of iconoclasm is more particularly to the use of images as supports of contemplation. The same rule will apply. There are those, the great majority, whose contemplation requires such supports, and others, the minority, whose vision of God is immediate. For the latter to think of God in terms of any verbal or visual concept would be the same as to forget him.[77] We cannot make one rule apply to

both cases. The professional iconoclast is such either because he does not understand the nature of images and rites, or because he does not trust the understanding of those who practice iconolatry or follow rites. To call the other man an idolater or superstitious is, generally speaking, only a manner of asserting our own superiority. Idolatry is the misuse of symbols, a definition needing no further qualifications. The traditional philosophy has nothing to say against the use of symbols and rites ; though there is much that the most orthodox can have to say against their misuse. It may be emphasized that the danger of treating verbal formulae as absolutes is generally greater than that of misusing plastic images.

We shall consider only the *use* of symbols, and their rejection when their utility is at an end. A clear understanding of the principles involved is absolutely necessary if we are not to be confused by the iconoclastic controversies that play so large a part in the histories of every art. It is inasmuch as he " knows immortal things by the mortal " that the man as a veritable person is distinguished from the human animal, who knows only the things as they are in themselves and is guided only by this estimative knowledge. The unmanifested can be known by analogy ; His silence by His utterance. That " the invisible things of Him " can be seen through " the things which are made " will apply not only to God's works but also to things made by hands, if they have been made by such an art as we have tried to describe : " In these outlines, my son, I have drawn a likeness of God for you, as far as that is possible ; and if you gaze upon this likeness with the eyes of your heart . . . the sight itself will guide you on your way."[78] This point of view Christianity inherited from Neoplatonism : and therefore, as Dante says, " doth the Scripture condescend to your capacity, assigning foot and hand to God, with other meaning." We have

no other language whatever except the symbolic in which to speak of ultimate reality : the only alternative is silence ; in the meantime, " The ray of divine revelation is not extinguished by the sensible imagery wherewith it is veiled."[79]

" Revelation " itself implies a veiling rather than a disclosure : a symbol is a " mystery."[80] " Half reveal and half conceal " fitly describes the parabolic style of the scriptures and of all conceptual images of being in itself, which cannot disclose itself to our physical senses. Because of this Augustine could say that in the last analysis "All scripture is vain." For " If any one in seeing God conceives something in his mind, this is not God, but one of God's effects " :[81] " We have no means for considering how God is, but rather how he is not " :[82] there are " things which our intellect cannot behold . . . we cannot understand what they are except by denying things of them."[83] Dicta to this effect could be cited from innumerable sources, both Christian and Oriental.

It does not follow that the spiritual tradition is at war with itself with respect to the use of conceptual images. The controversy that plays so large a part in the history of art is maintained only by human partisans of limited points of view. As we said before, the question is really one of utility only : it parallels that of works and faith. Conceptual images and works alike, art and prudence equally, are means that must not be mistaken for ends ; the end is one of beatific contemplation, not requiring any operation. One who proposes to cross a river needs a boat; " but let him no longer use the Law as a means of arrival when he has arrived."[84] Religious art is simply a visual theology : Christian and Oriental theology alike are means to an end, but not to be confused with the end. Both alike involve a dual method, that of the *via affirmativa* and of the *via negativa* ; on

the one hand affirming things of God by way of praise, and on the other denying every one of these limiting descriptive affirmations, for though the worship is dispositive to immediate vision, God is not and never can be "what men worship here."[85] The two ways are far from mutually exclusive ; they are complementary. Because they are so well known to the student of Christian theology I shall only cite from an Upanishad, where it is a question of the use of certain types of concepts of deity regarded as supports of contemplation. Which of these is the best ? That depends upon individual faculties. But in any case, these are pre-eminent aspects of the incorporeal deity ; " These one should contemplate and praise, but then deny. For with these one rises from higher to higher states of being. But when all these forms are resolved, then he attains to the unity of the Person."[86]

To resume : the normal view of art that we have described above, starting from the position that " Though he is an artist, the artist is nevertheless a man," is not the private property of any philosopher, or time, or place : we can only say that there are certain times, and notably our own, at which it has been forgotten. We have emphasized that art is for the man, and not the man for art : that whatever is made only to give pleasure is a luxury and that the love of art under these conditions becomes a mortal sin ;[87] that in traditional art function and meaning are inseparable goods ; that it holds in both respects that there can be no good use without art ; and that all good uses involve the corresponding pleasures. We have shown that the traditional artist is not expressing himself, but a thesis : that it is in this sense that both human and divine art are expressions, but only to be spoken of as " self-expressions " if it has been clearly understood what " self " is meant. We have shown that the traditional

artist is normally anonymous, the individual as such being only the instrument of the "self" that finds expression. We have shown that art is essentially symbolic, and only accidentally illustrative or historical ; and finally that art, even the highest, is only the means to an end, that even the scriptural art is only a manner of "seeing through a glass, darkly," and that although this is far better than not to see at all, the utility of iconography must come to an end when vision is "face to face."[88]

NOTES AND BIBLIOGRAPHY

[1] *Crede ut intelligas, intellige ut credas.* " Through faith we understand " (Jas. V. 15). " The nature of faith . . . consists in knowledge alone " (St. Thomas Aquinas, *Sum. Theol.* II-II. 47. 13 ad 2).

[2] *Ars nihil quod recta ratio factibilium. Omnis applicatio rationis rectae ad aliquid factibile pertinet ad artem ; sed ad prudentiam non pertinet nisi applicatio rationis rectae ad ca de quibuis est consilium. Prudentia est recta ratio agibilium.* (St. Thomas Aquinas, *Sum. Theol.* I-II. 57. 5 ; II-II. 47. 2 ; IV. 3. 7 and 8. Aristotle *Ethic.* VI. 5).

[3] Cf. Plotinus, *Enneads* IV. 3. 7.

[4] *Per artem et ex voluntate* (St. Thomas Aquinas, *Sum. Theol.,* I. 45. 6, cf. 1. 14. 8c).

[5] St. Thomas Aquinas, *Sum. Theol.,* I-II. 57. 5 : II-II. 21. 2 ad 2 ; 47. 8 ; 167.2 ; and 169. 2 ad 4.

[6] *Ib.,* I. 91. 3 ; and I-II. 57. 3 ad 2 (" It is evident that a craftsman is inclined by justice, which rectifies his will, to do his work faithfully ").

[7] *Ib.* I-II. 57. 3. ad 1.

[8] *Ib.* I-II. 33. 4.

[9] *Bhagavada Gītā,* XVIII. 45-46, *sve sve karmaṇy-abhirataḥ saṃsiddham labhate naraḥ,* etc. "And if man takes upon him in all its fullness the proper office of his own vocation (*curam propriam diligentiae suae*), it is brought about that both he and the world are the means of right order to one another. . . . For since the world is God's handiwork, he who maintains and heightens its beauty by his tendance (*diligentia*) is co-operating with the will of God, when he by the aid of his bodily strength, and by his work and his administration (*opere curaque*) composes any figure that he forms in accordance with the divine intention (*cum speciem, quam ille intentione formavit . . . componit*). What shall be his reward ? . . . that when we are retired from office (*emeritos*) . . . God will restore us to the nature of our better part, that is divine " (Hermetica, *Asclepius,* I. 10, 12). In this magnificent definition of the artist's function, it may be noted that *cura propria* corresponds to the *svakarma* of the *Bhagavad*

WHY EXHIBIT WORKS OF ART ?

Gītā and that *diligentia* (from *diligo*, to love) becomes "tendance" in precisely the same way that *ratah* (from *ram*, to take delight in) becomes "intent upon" or "devoted to." It is the man who while at work is doing what he likes best that can be called "cultured."

[10] *Nec oportet, si liberales artes sunt nobiliores, quod magis eis conveniat ratio artis* (St. Thomas Aquinas, *Sum. Theol.*, I-II. 57. 3 ad 3). "The productions of all arts are kinds of poetry and their craftsmen are all poets" (Plato, *Symposium*, 205 c).

[11] Plato, *Gorgias*, 503. In Rigveda IX. 112 the work of the carpenter, doctor, fletcher and sacrificial priest are all alike treated as ritual "operations," or "rites" (*vrata*).

[12] *Analects*, III. 25.

[13] Plato, *Cratylus*, 416 c ; Dionysius Areopagiticus, *De div. nom.* IV. 5 ; Ulrich of Strassburg, *De pulchro* ; *Lankâvatâra Sûtra*, II. 118-9, etc.

[14] *Ens et bonum convertuntur.*

[15] Witelo, *Perspectiva*, IV. 148-9. Baeumker, *Witelo*, p. 639, fails to see that Witelo's recognition of the subjectivity of *taste* in no way contradicts his enunciation of the objectivity of *beauty*. Taste is a matter of the affections ; beauty one of judgment, which is "the perfection of art" (St. Thomas Aquinas, *Sum. Theol.*, II-II. 47. 8.), where there is no room for preferences, art being comparable to science in its certainty, and differing from science only in being ordered to operation.

[16] Hasak, M., *Kirchenbau des Mittelalters*, 2nd ed., Leipzig, 1913, p. 268.

[17] Said by the Parisian Master Jean Mignot in connection with the building of the cathedral of Milan in 1398, in answer to the opinion *scientia est unum et ars aliud. Scientia reddit opus pulchrum.* St. Bonaventura, *De reductione artium ad theologiam* 13. *Nam qui canil quod non sapil, diffinitur bestia . . . Non verum facil ars cantorem, sed documentum,* Guido d'Arezzo. The actual distinction of science from art is drawn by St. Thomas Aquinas in *Sum. Theol.*, I. 14. 8 and I-II. 57. 3 ad 3 : both have to do with cognition, but whereas science has in view a knowledge only, art is ordered to an external operation. It will be seen that the greater part of modern science is what the medieval philosopher would have called an art, the engineer, for example, being essentially an artist, despite the fact that "without science art would be nothing" —but guesswork. "The antithesis between science and art is a false one, maintained only by the incurably, if enjoyably, sentimental" (Professor Crane Brinton, in *The American Scholar*, 1938, p. 152).

[18] Firth, R., *Art and life in New Guinea*, 1936, p. 9.

[19] Boethus, *De consol.* I. 6. 45.

[20] Math. IV. 4.

[21] Dante, *Ep. ad Can. Grand.* 15, 16 : "The whole work was undertaken not for a speculative but a practical end. . . . The purpose of the whole is to remove those who are living in this life from the state of wretchedness and to lead them to the state of blessedness." Ashvaghosha, *Saundârananda*, colophon : "This poem, pregnant with the burden of Liberation, has been composed by me in the poetic manner, not for the sake of giving pleasure, but for the sake of giving peace, and to win over other-minded hearers. If I have dealt in it with subjects other than that of Liberation, that pertains to what is proper to poetry, to make it tasty, just as when honey is mixed with a sour medicinal herb to make it drinkable. Since I beheld the world for the most part given

over to objects of sense and disliking to consider Liberation, I have spoken here of the Principle in the garb of poetry, holding that Liberation is the primary value. Whoever understands this, let him retain what is set forth, and not the play of fancy, just as only the gold is cared for when it has been separated from the ore and dross." "Dante and Milton claimed to be didactic ; we consider the claim a curious weakness in masters of style whose true but unconscious mission was to regale us with ' aesthetic emotion '." (Walter Shewring in *Integration*, II. 2, Oct.-Nov., 1938, p. 11.).

Dante's " practical purpose " is precisely what Guido d'Arezzo means by *usus* in the lines,

> Musicorum et cantorum magna est distancia :
> Isti dicunt, illi sciunt quae componit musica.
> Nam qui canit quod non sapit, diffinitur bestia ;
> Bestia non cantor qui non canit arte, sed usu ;
> Non verum facit ars cantorem, sed documentum.

I.e. " Between the ' virtuosi ' and the ' singers ' the difference is very great : the former merely vocalize, the latter understand the music's composition. He who sings of what he savours not is termed a ' brute ' ; no ' brute ' is he who sings, not merely artfully, but usefully ; it is not art alone, but the theme that makes the real ' singer '."

Professor Lang, in his *Music and Western Civilisation*, p. 87, misunderstands the penultimate line, which he renders by "A brute by rote and not by art produces melody," a version that ignores the double negative and misinterprets *usu*, which is not "by habit" but "usefully" or "profitably," ὠφελίμως. The thought is like St. Augustine's, "not to enjoy what we should use," and Plato's, for whom the Muses are given us "that we may use them intellectually (μετὰ νοῦ), not as a source of irrational pleasure (ἐφ'ἡδονὴν ἀ'λογον) but as an aid to the revolution of the soul within us, of which the harmony was lost at birth, to help in restoring it to order and concent with its Self" (*Timaeus* 47 D, cf. 90 D). The words *sciunt quae componit musica* are reminiscent of Quintillian's *Docti rationem componendi intelligunt, etiam indocti voluptatem* (IX. 4. 116), based on and almost a literal translation of Plato, *Timaeus* 80 B. *Sapit*, as in *sapientia*, " scientia cum amore."

[22] *Aitareya Āraṇyaka*, II. 3. 2 : *Aitareya Brāhmaṇa*, VII. 10 ; *Kaṭha Upanishad*, II. 10 b.

[23] Rom. I. 20. St. Thomas Aquinas repeatedly compares the human and divine architects : God's knowledge is to his creation as is the artist's knowledge of art to the things made by art (*Sum. Theol.* I. 14. 8 : I. 17. 1 ; I. 22. 2 ; I. 45. 6 ; I-II. 13. 2 ad 3).

[24] Cf. " Le symbolisme de l'epée " in *Études Traditionelles* 43, Jan., 1938.

[25] Lethaby, W. R., *Architecture, Mysticism and Myth*, London, 1892 : my " Symbolism of the Dome," *Indian Historical Qtly*. XVI, 1938, pp. 1-56.

[26] Keith, A. B., *Aitareya Āraṇyaka*, p. 42. " The first principle of democracy . . . is that no one knows the final truth about anything " (W. H. Auden, in the *Nation*, March 25, 1939, p. 353). " For there is a rancour that is contemptuous of immortality, and will not let us recognize what is divine in us " (Hermetica, *Asclepius*, I. 12 b).

[27] " To make the primordial truth intelligible, to make the unheard audible, to enunciate the primordial word, to represent the archetype, such is the task of art, or it is not art " (Andrae, W., " Keramik im

Dienste der Weisheit" in *Berichte de Deutschen Keramischen Gesellschaft*, XVII, Dec., 1936, p. 623) : but "The sensible forms, in which there was at first a polar balance of the physical and metaphysical, have been more and more voided of content on their way down to us, and so we say ' This is an ornament ' " (Andrae, W., *Die ionische Saüle, Bauform oder Symbol* ? 1933, p. 65).

[28] St. Thomas Aquinas, *Sum. Theol.*, I. 5. 4 : St. Basil, *De Spir. Sanct.* XVIII. 45. " The first perfection of a thing consists in its very form, from which it receives its species " (St. Thomas Aquinas, *ib.* III. 29. 2 c). The form that is the perfection of the thing (its exemplary form) is the standard by which the actual form of the thing itself is judged : in other words, it is by their ideas that we know what things ought to be like (St. Augustine, *De Trin.*, IX. 6, 11), and not by any observation or recollection of already existing things. Our authors commonly speak of the arch as an illustration of an exemplary form ; thus St. Augustine, *ib.*, and St. Bonaventura, *II Sent.*, d. 1, p. 1, a. 1, q ad 3, 4 *Agens per intellectum producit per formas, quae sunt aliquid rei, sed idea in mente sicut artifex producit arcam.*

[29] Natura naturans, Creatrix Universalis, Deus, from whom all natured things derive their specific aspect.

[30] " The perfect Word, not wanting in anything, and, so to speak, the art of God " (St. Augustine, *De Trin.* VI. 10). " Der sun ist ein verstentnisse des vaters und ist bildner (architect) aller dinge in sinem vater " (Eckhart, Pfeiffer, p. 391). " Through him all things were made " (John I. 3).

[31] *Omnes enim rationes exemplares concipuntur ab aeterno in vulva aeternae sapientiae seu utero*, St. Bonaventura, *In Hexaem*, coll, 20, n. 5. The conception of an imitable form is a "vital operation," that is to say, a generation.

[32] *Per verbum in intellectu conceptum*, St. Thomas Aquinas, *Sum. Theol.*, I. 45. 6 c.

[33] *Hermetica, Lib.* I. 86, cf. Boethius, *De consol:* III, " Holding the world in His mind, and forming it into His image." " The divine essence, whereby the divine intellect understands, is a sufficient likeness of all things that are " (St. Thomas Aquinas, *Sum. Theol.*, I. 14. 12 c). Cf. my " Vedic Exemplarism " in *Harvard Journal of Asiatic Studies*, I, April, 1936.

[34] Śaṅkarācārya, *Svātmanirūpaṇa*, 95. On the world-picture as an actual form see Vimuktatman, as cited by Das Gupta, *History of Indian Philosophy*, II. 203. The perfection of judgment is represented in Genesis I. 31, " God saw everything that he had made, and behold it was very good." This judgment can only have been with respect to the ideal pattern pre-existent in the divine intellect, not with reference to any external standard.

[35] St. Augustine, as cited by Bonaventura, *I Sent.* d. 35, a. unic., q. 1, fund. 3 see Bissen, *L'exemplarisme divin selon St. Bonaventura*, 1929, p. 39.

[36] St. Augustine, *De Trin.* IX. 6, 11 ; see Gilson, *Introduction à l'étude de St. Augustin.*, 1931, p. 121.

[37] William Blake.

[38] Plato, *Republic*, 500 E.

[39] Gilson, *loc. cit.*, p. 121, note 2.

[40] For St. Bonaventura's " expressionism " see Bissen *loc. cit.*, pp. 92.93.

[11] Every mimetic rite is by nature a work of art ; in the traditional philosophy of art the artist's operation is also always a rite, and thus essentially a religious activity.

[42] Meister Eckhart.

[43] St. Thomas Aquinas, *Sum. Theol.*, II-II. 47. 4 ad 2.

[44] Dante, *Convito*, Canzone III. 53-54 and IV. 10.106. Plotinus, *Enneads*, IV. 4. 2. My "Intellectual operation in Indian art," *Journ. Indian Society of Oriental Art*, III, 1935, p. 6 note 5.

[45] Since in this case "Diu künste sint meister in dem meister" (Eckhart, Pfeiffer, p. 390).

[46] St. Bonaventura *I Sent.*, d. 36, a. 2 q. 1 ad 4 citing St. Augustine, *res factae . . . in artifice creato dicuntur vivere.*

[47] St. Augustine, *Enarratio in Ps. XXXII* : cf. in Ps. CXLVI *Vis ergo psallere ? Non solum vox tua sonet laudes Dei, sed opera tua concordent cum voce tua.* It is by no means necessary to exclude from "opera" here whatever is made *per artem et ex voluntate.*

[48] John I. 3, as cited by Sts. Augustine, Bonaventura, Aquinas, etc., see M. d'Asbeck, *La mystique de Ruysbroeck l'Admirable*, 1930, p. 159.

[49] Hermetica, *Asclepius*, prologue.

[50] Plotinus, *Enneads*, IV. 4. 2.

[51] *Purgatorio*, XXIV. 52-54. "In the making of things by art, do we not know that a man who has this God for his leader achieves a brilliant success, whereas he on whom Love has laid no hold is obscure ? " (Plato, *Symposium*, 197 A). "My doctrine is not mine, but his that sent me . . . He that speaketh of himself seeketh his own glory,' John VII. 16, 18.

[52] Exodus, XXV. 40.

[53] *Aitareya Brāhmaṇa*, VI. 27. Cf. *Śāṅkhāyana Āraṇyaka*, VIII. 9. "There is this celestial harp : this human harp is a likeness of it."

[54] Plotinus, *Enneads*, V. 9. 11. The builder and carpenter are then doing the will of God "on earth *as* it is done in heaven."

[55] Conf. XI. 5.

[56] "As regards the most lordly part of our soul, we must conceive of it in this wise : we declare that God has given to each of us, as his daemon, that kind of soul which is housed in the top of our body and which raises us—seeing that we are not an earthly but a heavenly plant—up from earth towards our kindred in heaven" (Plato, *Timaeus*, 90. A).

[57] "The artist in Viking times is not to be thought of as an individual, as would be the case to-day . . . It is a creative art" (Strzygowski, *Early Church Art in Northern Europe*, 1928, pp. 159-160) : "It is in the very nature of Medieval Art that very few names of artists have been transmitted to us . . . The entire mania for connecting the few names preserved by tradition with well-known masterpieces,—all this is characteristic of the nineteenth century's cult of individualism, based upon ideals of the Renaissance" (H. Swarzenski, in *Journal of the Walters Art Gallery*, I, 1938, p. 55). "The academic styles that have succeeded each other since the seventeenth century, as a consequence of this curious divorce of beauty from truth, can hardly be classified as Christian art, since they recognize no inspiration higher than the human mind" (C. R. Morey, *Christian Art*, 1935).

WHY EXHIBIT WORKS OF ART?

[57A] Plato, *Republic*, 342 B.C.

[58] St. Ambrose on 1 Cor. 12. 3, cited by St. Thomas Aquinas, *Sum. Theol.*, I-II. 109. 1 ad 1.

[59] The title of a work by St. Bonaventura.

[60] Quintillian, IX. 4.

[61] Luke, XVII. 33. Hence the repeated question of the Upanishads, " By which self is the *summum bonum* attainable ? " and the traditional " Know thyself."

[62] John, VIII. 28.

[63] *Bhagavad Gītā*, III. 27 ; V. 8. Cf. *Jaiminīya Upanishad Brāhmaṇa*, I. 5. 2 ; *Udāna* 70.

[64] *Dhammapada*, 74.

[65] E. D. and F. Andrews, *Shaker Furniture*, 1937, p. 44.

[66] See Jitta-Zadoks, *Ancestral portraiture in Rome*, 1932, pp. 87, 92 f. Tomb effigies about 1200 " represented the deceased not as he actually appeared after death but as he hoped and trusted to be on the Day of Judgment. This is apparent in the pure and happy expression of all the equally youthful and equally beautiful faces, which have lost every trace of individuality. But towards the end of the XIIIth century . . . not how they perhaps appear one day but how they had actually been in life was considered important. . . . As the last consequence of this demand for exact likeness the death mask, taken from the actual features, made its appearance . . . rationalism and realism appearing at the same time." Cf. my *Transformation of Nature in Art*, p. 91 and note 64, and " The traditional conception of ideal portraiture," *Twice a Year*, No. 3/4 (Autumn, 1939).

[67] Luke, XIV. 26.

[68] *De spiritu et littera*, 37.

[69] *Sum. Theol.*, I. 1. 9.

[70] John VIII. 58. Cf. *Bhagavad Gita* IV. 1, 4, 5 ; *Saddharma Puṇḍarīka*, XIV. 44 and XV. 1.

[71] *De fid. orthod.* III.

[72] *Sum. Theol.*, III. 33. 1.

[73] *Ib.* I. 5. 4 ad 1.

[74] *Ib.* I-II. 30. 1 c. Cf. Witelo, *Lib. de intelligentiis*, XVIII, XIX.

[75] St. Augustine, *De doc. christ.*, II. 31.

[76] Eckhart.

[77] Plotinus, *Enneads*, IV. 4. 6, " In other words, they have seen God and they do not remember ? Ah, no : it is that they see God still and always, and that as long as they see, they cannot tell themselves they have had the vision ; such reminiscence is for souls that have lost it." Nicolas of Cusa, *De vis. Dei*, Ch. XVI " What satisfies the intellect is not what it understands." *Kena Upanishad*, 30, " The thought of God is his by whom it is unthought, or if he thinks the thought, it is that he does not understand." *Vajracchedika Sutra*, f. 38 XXVI, " Those who see me in any form, or think of me in words, their way of thinking is false, they do not see me at all. The Beneficent Ones are to be seen in the Law, theirs is a Lawbody : the Buddha is rightly to be understood as being of the nature of the Law, he cannot be understood by any means."

[78] Hermetica, *Lib.* IV. 11 b.

CHRISTIAN AND ORIENTAL PHILOSOPHY OF ART

[79] St. Thomas Aquinas, *Sum. Theol.*, I. 1. 9.

[80] Clement of Alexandria, *Protr.* II. 15. Cf. René Guénon, "Mythes, Mystères et Symboles," in *Voile d'Isis* (*Études Traditionelles*) 40, 1935. That "revelation" means a "displaying" depends upon the fact that an exhibition of the principle in a likeness, and as it were clothed in the veil of analogy, though it is not an exhibition of the principle in its naked essence, is relatively to what would otherwise be the obscurity of a total ignorance, a true "demonstration."

[81] St. Thomas Aquinas, *Sum. Theol.*, III. 92. 1 ad 4.

[82] *Ib.* I. 3. 1. Cf. *Bṛhadāraṇyaka Upanishad*, IV. 4. 22 ; *Maitri Upanishad* IV. 5, etc.

[83] Dante, *Convito*, III. 15. Nicolas of Cusa, *De fil. Dei, Deus, cum non possit nisi negative, extra intellectualem regionem, attingi*. Eckhart, "Wilta komen in die kuntschaft der verborgenen heimelicheit gotes, so muostu übergan alles, daz dich gehindern mac an luterr bekentnisse, daz du begrifem maht mit verstentnisse" (Pfeiffer, p. 505).

[84] Parable of the raft, *Majjhima Nikāya*, I. 135 ; St. Augustine, *De spir. et lit.*, 16.

[85] *Kena Upanishad*, 2-8.

[86] *Maitri Upanishad*, IV. 5.

[87] For the conditions under which ornamentation becomes a sin, see St. Thomas Aquinas, *Sum. Theol.*, II-II. 167. 2 and 169. 2 ad 4. Cf. my "On the relation of beauty to truth" in *Art Bulletin*, XX, pp. 72-77, and "ornament," d. XXI.

[88] I Cor. 13. 12.

SHORT BIBLIOGRAPHY FOR THE PHILOSOPHY OF MEDIÆVAL AND ORIENTAL ART

Adler, M., *Art and Prudence*, Chicago, 1935.

Anitchkoff, E., "L'estétique au moyen-âge," *Le Moyen Age*, XX (1917-18), 221-258.

Andræ, W., *Die ionische Saüle, Bauform oder Symbol?* Berlin, 1933. "Keramik in Dienste der Weisheit," in *Berichte der Deutschen Keramischen Gesellschaft*, December, 1936.

Bauemker, C., *Witelo*, Münster, 1908.

Baldwin, C. S., *Mediæval Rhetoric and Poetic*, New York, 1928.

Bissen, J. M., *L'Exemplarisme divin selon St. Bonaventura*, Paris, 1929.

St. Augustine, *De doctrina christiana* Catholic University of America, Patristic Studies, Vol. XXXIII.

St. Bonaventura, *De reductione artium ad theologiam*, in Opera Omnia.

Carey A. Graham, "The Catholic attitude towards art," in *Catholic Social Art, Qtly.* Vol. I, pt. 4, 1938.

Pattern Newport 1938.

Coomaraswamy, A. K., *The Indian craftsman*, London, 1909. *The transformation of nature in art*, Cambridge, 1935. *The Mirror of Gesture*, New York, 1936. "The technique and theory of Indian painting," in *Technical Students in the Field of the Fine Arts*, III, 1934. "The intellectual operation in Indian art," in *JISOA*, June 1935. *Is art a superstition or a way of life?* Newport, 1937. "Mediæval Æsthetic," pts. I and II, *Art Bulletin*, vols. XVII, XX. "The nature of Buddhist art," in Rowland and Coomaraswamy, *Wall paintings of India, Central Asia and Ceylon*, Boston, 1938.

Asiatic Art, Chicago, 1938.

" The part of art in Indian life," in *The Cultural Heritage of India*, Calcutta (1937), Vol. III, pp. 485-513.

" The philosophy of Mediæval and Oriental Art," in *Zalmoxis*, I, 1938.

" Ornament " in *Art Bulletin*, XXI, 1939.

Coomaraswamy and Carey, A. Graham, *Patron and Artist*, Norton, 1936.

Coomaraswamy, Benson and Carey, *What use is art anyway ?* Newport, 1937.

De Fonseka, L., *On the truth of decorative art*, London, 1913.

Gleizes, A., *Vers une conscience plastique, La forme et l'histoire*, Paris, 1932.

Homocentrisme, Sablons (*Isère*), 1937.

Ghyka, M. C., *Le monbre d'or*, 2 vols., Paris, 1931.

Gill, E., *Beauty looks after herself*, London, 1933.

Work and leisure, London, 1934.

Art, London, 1934.

Work and culture, Newport, 1939.

Autobiography, London, 1941.

Guénon, R., " Mythes, Mystères et Symboles," in *Études Traditionelles*, 40, 1935.

" Initiation and the Crafts," *Journ. Indian Society of Oriental Art*, VI, 1938.

Healy, E. Th., *Saint Bonaventura's De reductione artium ad theologiam*, New York, 1940.

Lang, P. H., *Music in Western Civilization*, New York, 1941.

La Meri, *The Gesture Language of the Hindu Dance*, New York, 1941.

Lebasquais, É., " L'architecture sacrée," in *Études Traditionelles*, 41, 1936.

Lethaby, W. R., *Architecture, Mysticism and Myth*, London, 1891.

Longinus, *On the Sublime*.

Lund, F. M., *Ad Quadratum : a study of the geometrical bases of classic and mediæval religious architecture*, 2 vols., London, 1921.

Maritain, A., *Art and Scolasticism*, London, 1931.

Masson, Oursel, " L'esthétique indienne," *Rev. de.Metaphysique et de Morale*, July, 1936.

Plotinus, *Enneads*.

Renz, O., *Die Synteresis nach dem hl. Thomas von Aquin*, Münster, 1911.

Schlosser, J., *Die Kunstliteratur*, Vienna, 1924.

Shewring, W., " Booklearning and education," *Integration*, II, pt. 2, October-November, 1938.

Spinden, H., " Primitive Arts," in *Brooklyn Museum Qtly.*, October, 1935.

Strzygowski, J., *Spüren indo-germanisches Glaubens in der bildenden Kunst*, Heidelberg, 1936.

Svoboda, K., *L'esthétique de St. Augustin*, Brno, 1933.

Takács, Z., *The art of Greater Asia*, Budapest, 1933.

Tea, E., " Witelo," in *L'Arte*, XXX, 1927.

St. Thomas Aquinas, *Summa Theologica*.

De pulchro (on Dionysius, *De div. nom.*, IV. 5), in Opera Omnia, Parma, 1864 (as op. vii.c.iv, lect. 5). (See Art Bulletin XX, 1938, pp. 66-72).

Ulrich of Strassburg, *De pulchro* (on Dionysius, *De div. nom.*, IV. 5) (see *Art Bulletin*, XVII, 1935, pp. 31-47).

Warner, L., " On teaching the Fine Arts," in *American Review*, March, 1937.

Zimmer, H., *Kunstform and Yoga im indischen Kultbild*, Berlin, 1936.

III

IS ART A SUPERSTITION, OR
A WAY OF LIFE?

BY a superstition we mean something that "stands over" from a former time, and which we no longer understand and no longer have any use for. By a way of life, we mean a habit conducive to man's good, and in particular to the attainment of man's last and present end of happiness.

It seems to be a matter of general agreement at the present day that "Art" is a part of the higher things of life, to be enjoyed in hours of leisure earned by other hours of inartistic "Work." We find accordingly as one of the most obvious characteristics of our culture a class division of artists from workmen, of those for example who paint on canvas from those who paint the walls of houses, and of those who handle the pen from those who handle the hammer. We are certainly not denying here that there is a distinction of the contemplative from the active life, nor of free from servile operation : but mean to say that in our civilization we have in the first place made an absolute divorce of the contemplative from the active life, and in the second place substituted for the contemplative life an æsthetic life,—or as the term implies, a life of pleasure. We shall return to this point. In any case we have come to think of art and work as incompatible, or at least independent, categories and have for the first time in history created an industry without art.

Individualists and humanists as we are, we attach an inordinate value to personal opinion and personal

experience, and feel an insatiable interest in the personal experiences of others ; the work of art has come to be for us a sort of autobiography of the artist. Art having been abstracted from the general activity of making things for human use, material or spiritual, has come to mean for us the projection in a visible form of the feelings or reactions of the peculiarly-endowed personality of the artist, and especially of those most peculiarly-endowed personalities which we think of as " inspired " or describe in terms of genius. Because the artistic genius is mysterious we, who accept the humbler status of the workman, have been only too willing to call the artist a " prophet," and in return for his " vision " to allow him many privileges that a common man might hesitate to exercise. Above all we congratulate ourselves that the artist has been " emancipated " from what was once his position as the servant of church or state, believing that his mysterious imagination can operate best at random ; if an artist like Blake still respects a traditional iconography we say that he is an artist in spite of it, and if as in Russia or Germany the state presumes to conscript the artist, it is even more the principle involved than the nature of the state itself that disturbs us. If we ourselves exercise a censorship necessitated by the moral inconvenience of certain types of art, we feel it needful at least to make apologies. Whereas it was once the highest purpose of life to achieve a freedom *from* oneself, it is now our will to secure the greatest possible measure of freedom *for* oneself, no matter from what.

Despite the evidence of our environment, with its exaggerated standards of living, and equally depreciated standards of life, our conception of history is optimistically based on the idea of " progress " ; we designate cultures of the past or those of other peoples as relatively " barbaric " and our own as relatively " civilised,"

never reflecting that such prejudgments, which are really wish-fulfillments, may be very far from fact. The student of the history of art discovers, indeed, in every art cycle a decline from a primitive power to a refinement of sentimentality or cynicism. But being a sentimentalist, materialist, cynic, or more briefly a humanist himself, he is able to think what he likes, and to argue that the primitive or savage artist " drew like that " because he knew no better ; because he (whose knowledge of nature was so much greater and more intimate than that of the " civilized " or " city " man) had not learnt to see things as they are, was not acquainted with anatomy or perspective, and therefore drew like a child ! We are indeed careful to explain when we speak of an imitation of nature or study of nature we do not mean a " photographic " imitation, but rather an imitation of nature as experienced by the individual artist, or finally a representation of the nature of the artist as experienced by himself. Art is then " self-expression," but still an imitation of nature as effect, and essentially figurative rather than formal.

On the other hand we have said to ourselves that in the greatest works of art there is always a quality of abstraction, and have invoked the Platonic endorsement of a geometrical beauty ; we have said, Go to, let us also make use of abstract formulae. It was overlooked here that the abstract formulae of ancient art were its natural vehicle, and not a personal or even local invention but the common language of the world. The result of the modern interest in abstraction as such, and apart from questions of content and communicability, has been indeed to eliminate recognizability in art, but scarcely to modify its still essentially representative purpose. Personal symbolisms have been evolved which are not based on any natural correspondences of things to principles, but rather on private associations

of ideas. The consequence is that every abstract artist must be individually "explained" : the art is not communicative of ideas, but like the remainder of contemporary art, only serves to provoke reactions.

What is then the peculiar endowment of the artist, so much valued ? It is evidently, and by general consent, a special sensibility, and it is just for this reason that the modern terms "æsthetic" and "empathy" have been found so appropriate. By sensibility we mean of course an emotional sensibility ; *aisthesis* in Hellenistic usage implying physical affectibility as distinguished from mental operations. We speak of a work of art as "felt" and never of its "truth," or only of its truth to nature or natural feeling ; "appreciation" is a "feeling into" the work. Now an emotional reaction is evoked by whatever we like (or dislike, but as we do not think of works of art as intended to provoke disgust, we need only consider them here as sources of pleasure) : what we like, we call beautiful, admitting at the same time that matters of taste are not subject to law. The purpose of art is then to reveal a beauty that we like or can be taught to like ; the purpose of art is to give pleasure ; the work of art as the source of pleasure is its own end ; art is for art's sake. We value the work for the pleasure to be derived from the sight, sound, or touch of its æsthetic surfaces ; our conception of beauty is literally skin-deep ; questions of utility and intelligibility rarely arise, and if they arise are dismissed as irrelevant. If we propose to dissect the pleasure derived from a work of art, it becomes a matter of psycho-analysis, and ultimately a sort of science of affections and behaviours. If we nevertheless sometimes make use of such high-sounding expressions as "significant form," we do so ignoring that nothing can properly be called a "sign" that is not significant *of* something other than itself, and for the

sake of which it exists. We think of " composition " as an arrangement of masses designed for visual comfort, rather than as determined by the logic of a given content. Our theoretical knowledge of the material and technical bases of art, and of its actual forms, is encyclopædic ; but we are either indifferent to its *raison d'être* and final cause, or find this ultimate reason and justification for the very existence of the work in the pleasure to be derived from its beauty by the patron. We say the patron ; but under present conditions, it is oftener for his own than for the patron's pleasure that the aritst works ; the perfect patron being nowadays, not the man who knows what he wants, but the man who is willing to commission the artist to do whatever he likes, and thus as we express it, " respects the freedom of the artist." The consumer, the man, is at the mercy of the manufacturer for pleasure (the " artist ") and manufacturer for profit (the " exploiter ") and these two are more nearly the same than we suspect.

To say that art is essentially a matter of feeling is to say that its sufficient purpose is to please ; the work of art is then a luxury, accessory to the life of pleasure. It may be enquired, Are not pleasures legitimate ? Do not the office worker and factory hand deserve and need more pleasures than are normally afforded by the colourless routine of wage-earning tasks ? Assuredly. But there is a profound distinction between the deliberate pursuit of pleasure and the enjoyment of pleasures proper to the active or contemplative life. It is one of the gratest counts against our civilization that the pleasures afforded by art, whether in the making or of subsequent appreciation, are not enjoyed or even supposed to be enjoyed by the workman at work. It is taken for granted that while at work we are doing what we like least, and while at play what we should wish to be doing all the time. And this is a part of

what we meant by speaking of our depreciated standards of life : it is not so shocking that the workman should be underpaid, as that he should not be able to delight as much in what he does for hire as in what he does by free choice. As Meister Eckhart says, " the crafts-man likes talking of his handicraft " : but, the factory worker likes talking of the ball game ! It is an in-evitable consequence of production under such condi-tions that quality is sacrificed to quantity : an industry without art provides a necessary apparatus of existence, houses, clothing, frying pans, and so forth, but an apparatus lacking the essential characteristics of things made by art, the characteristics, viz., of beauty and significance. Hence we say that the life that we call civilized is more nearly an animal and mechanical life than a human life ; and that in all these respects it contrasts unfavourably with the life of savages, of American Indians for example, to whom it had never occurred that manufacture, the activity of making things for use, could ever be made an artless activity.

Most of us take for granted the conception of art and artists outlined above and so completely that we not only accept its consequences for ourselves, but mis-interpret the art and artists of former ages and other cultures in terms that are only appropriate to our own historically provincial point of view. Undisturbed by our own environment, we assume that the artist has always been a peculiar person, that artist and patron have always been at cross purposes, and that work has always been thought of as a necessary evil. But let us now consider what we have often called the " normal view of art," meaning by " normal " a theory not merely hitherto and elsewhere universally accepted as basic to the structure of society, but also a correct or upright doctrine of art. We shall find that this normal, tradi-tional, and orthodox view of art contradicts in almost

every particular the æsthetic doctrines of our time, and shall imply that the common wisdom of the world may have been superior to our own, adding that a thorough understanding of the traditional meaning of " art " and theory of " beauty " are indispensable for the serious student of the history of art, whose business it is to explain the genesis of works of art produced for patrons with whose purposes and interests we are no longer familiar.

To begin with, then, the active life of a man consists on the one hand in doing, and on the other in making or arranging things with a view to efficient doing : broadly speaking, man as doer is the patron, and man as maker the artist. The patron knows what purpose is to be served, for example, he needs shelter. The artist knows how to construct what is required, namely a house. Everyone is naturally a doer, patron, and consumer ; and at the same time an artist, that is to say a maker by art, in some specialized sense, for example either a painter, carpenter, or farmer. There is a division of labour, and for whatever a man does not make for himself he commissions another professional, the shoemaker, for example, when he needs shoes, or the author when he needs a book. In any case, in such relatively unanimous societies as we are considering, societies whose form is predetermined by traditional conceptions of order and meaning, there can hardly arise an opposition of interest as between patron and artist ; both require the same kind of shoes, or worship at the same shrines, fashions changing only slowly and imperceptibly, so that under these conditions it has been truly said that " Art has fixed ends, and ascertained means of operation."

In the normal society as envisaged by Plato, or realized in a feudal social order or caste system, occupation is vocational, and usually hereditary ; it is

intended at least that every man shall be engaged in the useful occupation for which he is best fitted by nature, and in which therefore he can best serve the society to which he belongs and at the same time realize his own perfection. As everyone makes use of things that are made artfully, as the designation "artefact" implies, and everyone possesses an art of some sort, whether of painting, sculpture, blacksmithing, weaving, cookery or agriculture, no necessity is felt to explain the nature of art in general, but only to communicate a knowledge of particular arts to those who are to practise them ; which knowledge is regularly passed on from master to apprentice, without there being any necessity for "schools of art." An integrated society of this sort can function harmoniously for millennia, in the absence of external interference. On the other hand, the contentment of innumerable peoples can be destroyed in a generation by the withering touch of our civilization ; the local market is flooded by a production in quantity with which the responsible maker by art can not compete ; the vocational structure of society, with all its guild organization and standards of workmanship, is undermined ; the artist is robbed of his art and forced to find himself a "job" ; until finally the ancient society is industrialized and reduced to the level of such societies as ours, in which business takes precedence of life. Can one wonder that western nations are feared and hated by other peoples, not alone for obvious political or economic reasons, but even more profoundly and instinctively for spiritual reasons ?

What is art, or rather what was art ? In the first place the property of the artist, a kind of knowledge and skill by which he knows, not what ought to be made, but how to imagine the form of the thing that is to be made, and how to embody this form in suitable material, so that the resulting artefact may be used. The ship-

builder builds, not for æsthetic reasons, but in order that men may be able to sail on the water ; it is a matter of fact that the well-built ship will be beautiful, but it is not for the sake of making something beautiful that the shipbuilder goes to work ; it is a matter of fact that a well made icon will be beautiful, in other words that it will please when seen by those for whose use it was made, but the imager is casting his bronze primarily for use and not as a mantelpiece ornament or for the museum showcase.

Art can then be defined as the embodiment in material of a preconceived form. The artist's operation is dual, in the first place intellectual or " free " and in the second place manual and " servile." " To be properly expressed," as Eckhart says, " a thing must proceed from within, moved by its form." It is just as necessary that the idea of the work to be done should first of all be imagined in an imitable form as that the workman should command the technique by which this mental image can be imitated in the available material. " It is," as Augustine says, " by their ideas that we judge of what things ought to be like." A private property in ideas in inconceivable, since ideas have no existence apart from the intellect that entertains them and of which they are the forms ; there cannot be an authorship of ideas, but only an entertainment, whether by one or many ·intellects is immaterial. It is not then in the ideas to be expressed in art, or to speak more simply not in the themes of his work, that an artist's intellectual operation is spoken of as " free " ; the nature of the ideas to be expressed in art is predetermined by a traditional doctrine, ultimately of superhuman origin, and through the authority of which the necessity of a clear and repeated expression of such and such ideas has come to be accepted without question. As Aristotle expresses it, the general end of art is the

good of man. This is a matter of religious art only in this sense, that in a traditional society there is little or nothing that can properly be called secular ; whatever the material uses of artefacts, we find that what we, (who scarcely distinguish in principle art from millinery), describe as their ornamentation or decoration, has always a precise significance ; no distinction can be drawn between the ideas expressed in the humblest peasant art of a given period and those expressed in the actually hieratic arts of the same period. We cannot too often repeat that the art of a traditional society expresses throughout its range the governing ideology of the group ; art has fixed ends and ascertained means of operation ; art is a conscience about form, precisely as prudence is a conscience about conduct,—a conscience in both senses of the word, i.e., both as rule and as awareness. Hence it is that we can speak of a conformity or non-conformity in art, just as we can of regular and irregular, orderly and disorderly in conduct. Good art is no more a matter of moods than good conduct a matter of inclination ; both are habits ; it is the recollected man, and not the excited man, who can either make or do well.

On the other hand, nothing can be known or stated except in some way ; the way of the individual knower. Whatever may be known to you and me in common can only be stated by either of us each in our own way. At any given moment these ways of different individuals will be and are so much alike as to be pleasing and intelligible to all concerned ; but in proportion as the psychology and somatology of the group changes with time, so will the ways of knowing and idiom of expression ; an iconography may not vary for millennia, and yet the style of every century will be distinct and recognizable at a glance. It is in this respect that the intellectual operation is called free ; the style is the man, and

that in which the style of one individual or period differs from that of another is the infallible trace of the artist's personal nature ; not a deliberate, but an unconscious self-expression of the free man.

The orator whose sermon is not the expression of a private opinion or philosophy, but the exposition of a traditional doctrine, is speaking with perfect freedom, and originality ; the doctrine is his, not as having invented it, but by conformation (*adaequatio rei et intellectus*). Even in direct citation he is not a parrot, but giving out of himself a recreated theme. The artist is the servant of the work to be done ; and it is as true here as in the realm of conduct that " My service is perfect freedom." It is only a lip-service that can be called slavish ; only when an inherited formula has become an " art form," or " ornament," to be imitated as such without any understanding of its significance, that the artist, no longer a traditional craftsman but an academician, can properly be called a forger or plagiarist. Our repetition of classic forms in modern architecture is generally a forgery in this sense ; the manufacturer of " brummagen idols " is both a forger and a prostitute ; but the hereditary craftsman, who may be repeating formulæ inherited from the stone age, remains an original artist until he is forced by economic pressure to accept the status of a parasite supplying the demand of the ignorant tourist in search of drawing-room ornaments and what he calls " the mysterious East."

Where an idea to be expressed remains the same throughout long sequences of stylistic variation, it is evident that this idea remains the motif or motivating power behind the work ; the artist has worked throughout for the sake of the idea to be expressed, although expressing this idea always in his own way. The primary necessity is that he should really have

entertained the idea and always visualized it in an imitable form ; and this, implying an intellectual activity that must be ever renewed, is what we mean by originality as distinguished from novelty, and by power as distinguished from violence. It will readily be seen, then, that in concentrating our attention on the stylistic peculiarities of works of art, we are confining it to a consideration of accidents, and really only amusing ourselves with a psychological analysis of personalities ; not by any means penetrating to what is constant and essential in the art itself.

The manual operation of the artist is called servile, because similitude is with respect to the form ; in writing down, for example, the form of a musical composition that has already been heard mentally, or even in performance as such, the artist is no longer free, but an imitator of what he has himself imagined. In such a servility there is certainly nothing dishonourable, but rather a continued loyalty to the good of the work to be done ; the artist turns from intellectual to manual operation or vice versa at will, and when the work has been done, he judges its " truth " by measuring the actual form of the artefact against the mental image of it that was his before the work began and remains in his consciousness regardless of what may happen to the work itself. We can now perhaps begin to realize just what we have done in separating artist from craftsman and " fine " from " applied " art. We have assumed that there is one kind of man that can imagine, and another that cannot ; or to speak more honestly, another kind whom we cannot afford, without doing hurt to business, to allow to imagine, and to whom we therefore permit a servile and imitative operation *only*. Just as the operation of the artist who merely imitates nature as closely as possible, or as an archaist merely imitates the forms and formulæ of

ancient art without attempting any recreation of ideas
in terms of his own constitution, is a servile operation,
so is that of the mason required to carve, whether by
hand or machinery, innumerable copies or " orna-
ments " for which he is provided with ready-made
designs, for which another man is responsible, or which
may be simple " superstitions," that is to say " art
forms," of which the ideal content is no longer under-
stood, and which are nothing but the vestiges of originally
living traditions. It is precisely in our modern world
that everyone is nominally, and no one really " free."

Art has also been defined as " the imitation of nature
in her manner of operation " : that is to say, an
imitation of nature, not as effect, but as cause. Nature
is here, of course, " Natura naturans, Creatrix, Deus,"
and by no means our own already natured environment.
All traditions lay a great stress on the analogy of the
human and divine artificers, both alike being " makers
by art," or " by a word conceived in intellect." As the
Indian books express it, " We must build as did the
Gods in the beginning." All this is only to say again
in other words that " similitude is with respect to the
form." " Imitation " is the embodiment in matter of
a preconceived form ; and that is precisely what we
mean by " creation." The artist is the providence of
the work to be done.

All of our modern teaching centres round the posed
model and the dissecting room ; our conceptions of
portraiture are as a matter of historical fact associated
in their origins with the charnel house and death mask.
On the other hand, we begin to see now why primitive
and traditional and what we have described as normal
art is " abstract " ; it is an imitation, not of a visible
and transient appearance or " effect of light," but of
an intelligible form which need no more resemble
any natural object than a mathematical equation need

look like its locus in order to be " true." It is one thing to draw in linear rhythms and abstract light because one must ; another thing for anyone who is not by nature and in the philosophical sense a realist, deliberately to cultivate an abstracted style.

The principles of traditional criticism follow immediately from what has been said above. The work of art is " true " to the extent that its actual or accidental form reflects the essential form conceived in the mind of the artist (it is in this sense that the workman still speaks of " trueing " the work in hand) ; and adequate, or apt, if this form has been correctly conceived with respect to the final cause of the work, which is to be used by the patron. This distinction of judgments, which normally coincide in unanimous cultures, is of particular value to the modern student of ancient or exotic arts, for which we have no longer a practical use. The modern æsthetician thinks that he has done enough if he " feels into " the work, since he holds that the secret of art resides in a peculiar sensibility outwardly manifested as an æsthetic urge to express and communicate a feeling ; he does not realize that, ancient works of art were produced, devoutly indeed but primarily to serve a purpose and to communicate a gnosis. What was demanded of the traditional artist was first and foremost to be in possession of his art, that is to be in possession of a knowledge, rather than a sentiment. We forget that sensation is an animal property, and knowledge distinctly human ; and that art, if thought of as distinctly human and particularly if we think of art as a department of the " higher things of life," must likewise have to do much more with knowledge than with feeling. We ought not, then, as Herbert Spinden so cleverly puts it, to " accept a pleasurable effect upon our unintelligent nerve ends as an index of understanding."

IS ART A SUPERSTITION ?

The critic of ancient or exotic art, having only the work of art before him, and nothing but the æsthetic surfaces to consider, can only register reactions, and proceed to a dimensional and chemical analysis of matter, and psychological analysis of style. His knowledge is of the sort defined as accidental, and very different from the essential and practical knowledge of the original artist and patron. One can in fact only be said to have understood the work, or to have any more than a dilettante knowledge of it, to the extent that he can identify himself with the mentality of the original artist and patron. The man can only be said to have understood Romanesque or Indian art who comes very near to forgetting that he has not made it himself for his own use ; a man is only qualified to translate an ancient text when he has really participated in, and not merely observed, the outer and inner life of its time, and identified this time with his own. All this evidently requires a far longer, more round about, and self-denying discipline than is commonly associated with the study of the history of art, which generally penetrates no farther than an analysis of styles, and certainly not to an analysis of the necessary reasons of iconographies or logic of composition.

There is also a traditional doctrine of beauty. This theory of beauty is not developed with respect to artefacts alone, but universally. It is independent of taste, for it is recognized that as Augustine says, there are those who take pleasure in deformities. The word *de*formity is significant here, because it is precisely a formal beauty that is in question ; and we must not forget that " formal " includes the connotation " formative." The recognition of beauty depends on judgment, not on sensation ; the beauty of the æsthetic surfaces depending on their information, and not upon themselves. Everything, whether natural or artificial, is

beautiful to the extent that it really is what it purports to be, and independently of all comparisons ; or ugly to the extent that its own form is not expressed and realized in its tangible actuality. The work of art is beautiful, accordingly, in terms of perfection, or truth and aptitude as defined above ; whatever is inept or vague cannot be considered beautiful, however it may be valued by those who " know what they like." So far from that, the veritable connoisseur " likes what he knows " ; having fixed upon that course of art which is right, use has made it pleasant.

Whatever is well and truly made, will be beautiful in kind because of its perfection. There are no degrees of perfection ; just as we cannot say that a frog is any more or less beautiful than a man, whatever our preferences may be, so we cannot possibly say that a telephone booth as such is any more or less beautiful than a cathedral as such ; we only think that one is more beautiful than the other in kind, because our actual experience is of unlovely booths and really beautiful cathedrals.

It is taken for granted that the artist is always working " for the good of the work to be done " ; from the coincidence of beauty with perfection it follows inevitably that his operation always tends to the production of a beautiful work. But this is a very different matter from saying that the artist has always in view to discover and communicate beauty. Beauty in the master craftsman's atelier is not a final cause of the work to be done, but an inevitable accident. And for this reason, that the work of art is always occasional ; it is the nature of a rational being to work for particular ends, whereas beauty is an indeterminate end ; whether the artist is planning a picture, a song, or a city, he has in view to make that thing and nothing else. What the artist has in mind is to do the job " right," *secundum*

rectam rationem artis : it is the philosopher who brings in the word " beautiful " and expounds its conditions in terms of perfection, harmony, and clarity. A recognition of the fact that things can only be beautiful in kind, and not in one another's kinds, and the conception of the formality of beauty, bring us back again to the futility of a naturalistic art ; the beauties of a living man and of a statue or stone man are different in kind and not interchangeable ; the more we try to make the statue look like a man, the more we denature the stone and caricature the man. It is the form of a man in a nature of flesh that constitutes the beauty of this man ; the form of a man in a nature of stone the beauty of the statue ; and these two beauties are incompatible.

Beauty is, then, perfection apprehended as an attractive power ; that aspect of the truth for example which moves the will to grapple with the theme to be communicated. In mediæval phraseology, " beauty adds to the good an ordering to the cognitive faculty by which the good is known as such " ; " beauty has to do with cognition." If we ourselves endeavour to speak well, it is for the sake of clarity alone, and we should much rather be called interesting than mellifluent. To quote a Hasidic example : if any should say, " ' Let us now hear you talk of your doctrine, you speak so beautifully,' ' May I be struck dumb ere I speak beautifully '." But if beauty is not synonymous with truth, neither can it be isolated from the truth : the distinction is logical, but there is coincidence *in re*. Beauty is at once a symptom and an invitation ; as truth is apprehended by the intellect, so beauty moves the will ; beauty is always ordered to reproduction, whether a physical generation or spiritual regeneration. To think of beauty as a thing to be enjoyed apart from use is to be a naturalist, a fetishist, and an idolater.

WHY EXHIBIT WORKS OF ART?

Nothing more enrages the exhibitionist of modern art than to be asked, What is it about? or What is it for? He will exclaim, You might as well ask what it looks like! In fact, however, the question and answer are on altogether different planes of reference; we have agreed that the work of art by no means needs to look like anything on earth, and is perhaps the worse the more it tends to create an illusion. It is another matter if we demand an intelligibility and functional efficacy in the work. For what are we to do with it, intellectually or physically, if it has no meaning and is not adapted to be used? All that we can do in this case is to like it or dislike it, much as bulls are said to love green and hate red.

The intelligibility of traditional art does not depend on recognitions but, like that of script, on legibility. The characters in which this art is written are properly called symbols; when meaning has been forgotten or ignored and art exists only for the comfort of the eye, these become " art forms " and are spoken of as " ornaments " ; we speak of " decorative " values. Symbols in combination form an iconography or myth. Symbols are the universal language of art; an international language with merely dialectic variations, current once in all milieus and always intrinsically intelligible, though now no longer understood by educated men, and only to be seen or heard in the art of peasants. The content of symbols is metaphysical. Whatever work of traditional art we consider, whether a crucifix, Ionic column, peasant embroidery, or trappings of a horse, or nursery tale, has still, or had, a meaning over and above what may be called the immediate value of the object to us as a source of pleasure or necessity of life. This implies for us that we cannot pretend to have accounted for the genesis of any such work of art until we have understood what it was for and what it was intended to mean.

IS ART A SUPERSTITION ?

The symbolic forms, which we call ornaments because they are only superstitions for us, are none the less the substance of the art before us ; it is not enough to be able to use the terms of iconography freely and to be able to label our museum specimens correctly ; to have understood them, we must understand the ultimate *raison d'être* of the iconography, just why it is as it is and not otherwise.

Implicit in this symbolism lies what was equally for artist and patron the ultimately spiritual significance of the whole undertaking. The references of the symbolic forms are as precise as those of mathematics. The adequacy of the symbols being intrinsic, and not a matter of convention, the symbols correctly employed transmit from generation to generation a knowledge of cosmic analogies : as above, so below. Some of us still repeat the prayer, Thy will be done on earth as it is in heaven. The artist is constantly represented as imitating heavenly forms,—" the crafts such as building and carpentry which give us matter in wrought forms . . . take their principles thence and from the thinking there " (Enneads, V. 9). The archetypal house, for example, repeats the architecture of the universe ; a ground below, a space between, a vault above, in which there is an opening corresponding to the solar gateway by which one " escapes altogether " out of time and space into an unconfined and timeless empyrean. Functional and symbolic values coincide ; if there rises a column of smoke to the luffer above, this is not merely a convenience, but also a representation of the axis of the universe that pillars-apart heaven and earth, essence and nature, and is itself although without dimensions or consistency the adamantine principle and exemplary form of temporal and spatial extension and of all things situated in time or space. This was doubtless already apparent to prehistoric man, though

we cannot trace it farther back in literature than perhaps
a millennium and a half B. C. Vestiges of the primitive
luffer survive in the eyes of domes, and of its significance
in the fact that even to-day we speak of Santa Claus,
a doublet of the resurrected Sun, as entering in with
his gifts, not by the human door, but by the chimney.

The world-wide designation of stone weapons as
" thunder-bolts " is a memory surviving from the
Stone Age, when already primitive man identified his
striking weapons with the shaft of lightning with which
the solar Deity smote the Dragon, or if you prefer,
St. Michael Satan, in the beginning ; an iron age
inherits older traditions, and literary evidences for an
identification of weapons with lightning go back at
least as far as the second millennium B.C. All traditions
agree in seeing in the warp of tissues made by hand
an image of the fontal-raying of the dawn-light of
creation, and in their woof the representation of planes
of being or levels of reference more or less removed
from, but still dependent on their common centre
and ultimate support. Instances could be multiplied,
but it will suffice to say that the arts have been universally
referred to a divine source, that the practise of an art
was at least as much a rite as a trade, that the craftsman
had always to be initiated into the Lesser Mysteries
of his particular craft, and that the artefact itself had
always a double value, that of tool on the one hand
and that of symbol on the other. These conditions
survived in mediæval Europe, and still survive pre-
cariously in the East, to the extent that normal types
of humanity have been able to resist the subversive
influences of civilized business.

We are thus in a position to understand in part
how both the making of things by art, and the use of
things made by art subserved not only man's immediate
convenience, but also his spiritual life ; served in

other words the whole or holy man, and not merely the outer man who feeds on " bread alone." The transubstantiation of the artefact had its inevitable corollary in a transformation of the man himself ; the Templar, for example, whose sword was also a cross, had been initiated as and strove to become more than a man and as nearly as possible an hypostasis of the Sun. " The sword," as Rūmī says, is the same sword, but the man is not the same man (*Mathnawī* v. 3287). Now that the greater part of life has been secularized, these transformative values of art can be envisaged only in iconolatry, where the icon made by hands and subsequently consecrated serves as a support of contemplation tending towards a transformation of the worshipper into the likeness of the archetypal form to which, and " not to the colours or the art " as St. Basil says, the honour is paid. The collector who owns a crucifix of the finest period and workmanship, and merely enjoys its " beauty," is in a very different position from that of the equally sensitive worshipper, who also feels its power, and is actually moved to take up his own cross ; only the latter can be said to have understood the work in its entirety, only the former can be called a fetishist. In the same way, and as we have said elsewhere, the man who may have been a " barbarian " but could look upward to the roof tree of his house and say " There hangs the Light of Lights," or down to his hearth and say " There is the Centre of the World," was more completely a Man than one whose house, however well supplied with labour-saving and sanitary apparatus, is merely " a machine to live in."

It remains for us to consider the problems of artist and patron, producer and consumer, from the standpoint of ethics : to explain the traditional position, which asserts that there can be no " good use " without art ; that is to say no efficient goodness, but only good

intentions in case the means provided are defective.
Suppose for example, that the artist is a printer ; to the
extent that he designs an illegible type, the book, how-
ever supremely valuable its text, will be " no good."
Of a workman who bungles we say in the same way
that he is " no good " or " good for nothing," or in the
technical language of traditional ethics, that he is a
" sinner " : " sin " being defined as " any departure
from the order to the end," whatever the nature of the end.

Before the artist can even imagine a form there must
have been a direction of the will towards a specific
idea ; since one cannot imagine " form " in the
abstract, but only this or that form. In Indian terms,
an image can only spring from a " seed." Or as
Bonaventura expresses it, " Every agent acting ration-
ally, not at random, nor under compulsion, foreknows
the thing before it is, viz., in a likeness, by which
likeness, which is the ' idea ' of the thing (in an imitable
form), the thing is both known and brought into
being." The artist's will has accordingly consented
beforehand to the end in view ; whether a good end
or bad end is no longer his affair as an artist ; it is too
late now for qualms, and the artist as such has no longer
any duty but to devote himself to the good of the work
to be done. As St. Thomas expresses it, "Art does not
require of the artist that his act be a good act, but that
his work be good. . . . Art does not presuppose
rectitude of the appetite,"—but only to serve the
appetite, whether for good or evil. It is for the man to
decide what, if any, propaganda are desirable ; for
man as artist only to make the propagation effective.
The artist may nevertheless come short, and in this
case he is said to " sin as an artist " : if, for example,
he undertakes and proposes to manufacture an efficient
poison gas, and actually produces something quite
innocuous, or intends to fashion a Madonna, and only

produces a fashion plate. The artist as such is an amoral type : at the same time there can be no good use, that is effective use, without art.

Let us now remind ourselves that the artist is also a man, and as a man responsible for all that his will consents to ; " in order that a man may make right use of his art, he needs to have a virtue which will rectify his appetite." The man is responsible directly, as a murderer for example by intent if he consents to manufacture adulterated food, or drugs in excess of medical requirement ; responsible as a promoter of loose living if he exhibits a pornographic picture, (by which we mean of course something essentially salacious, preserving the distinction of " obscene " from " erotic "); responsible spiritually if he is a sentimentalist or pseudo-mystic. It is a mistake to suppose that in former ages the artist's " freedom " could have been arbitrarily denied by an external agency ; it is much rather a plain and unalterable fact that the artist as such is not a free *man*. As artist he is morally irresponsible, indeed ; but who can assert that he is an artist and not also a man ? The artist can be separated from the man in logic and for purposes of understanding ; but actually, the artist can only be divorced from his humanity by what is called a disintegration of personality. The doctrine of art for art's sake implies precisely such a sacrifice of humanity to art, of the whole to the part. It is significant that at the same time that individualistic tendencies are recognizable in the sphere of culture, in the other sphere of business and in the interest of profit most men are denied the opportunity of artistic operation altogether, or can function as responsible artists only in hours of leisure when they can pursue a " hobby " or play games. What shall it profit a man to be politically free, if he must be either the slave of " art," or slave of " business " ?

We say then that if the artist as such is morally irresponsible, he is also a morally responsible *man*. In the normal and long-enduring types of civilization that we have been considering,—Indian, Egyptian, early Greek, mediæval Christian, Chinese, Maori, or American Indian for example,—it has been man as patron rather than man as artist with whom the decision has rested as to *what* shall be made : the freedom of the artist involving an autonomy only within his own sphere of operation, and not including a free choice of themes. That choice remained with the Man, and amounted to an effective censorship, though not a censorship in our sense, but in the last analysis a self-control, since the artist and the man were still of one mind, and all men in some sense artists. Nothing in fact was made that did not answer to a generally recognized necessity.

All this accords with Aristotle's dictum, that " the general end of art is the good of man." General ends take precedence of private ends ; it is not the private good of this or that man, and still less of this or that artist, but Man's conception of the good, that has determined what was made by art. In principle, accordingly, a censorship can be approved of as altogether proper to the dignity of Man. This need not be a legally formulated censorship so long as the responsible artist is *also* a responsible member of society. But as soon as the artist asserts an absolute independence there arises the occasion for a formulated censorship ; liberty becoming license, forges its own chains.

We must not however overlook a factor essential to the current problem. Who is qualified to be a censor ? Surely it is not enough to recognize a wrong, or what we think a wrong, and to rush into action guided only by a private, or little group, opinion, however firmly entertained. It is certainly not in a democracy, nor in a society trying to find a means of survival by trial and

error, that a censorship can be justly exercised. Our censorships reflect at the best a variable canon of expediency ; one that varies, for example, from state to state and decade to decade. To justify the exercise of a censorship, we must *know* what is right or wrong, and why ; we must have read Eternal Law before we can impose a human code. This means that it is only within a relatively unanimous community, acknowledging an ascertained truth, that a censorship can properly be exercised, and only by an élite, whose vocation it is precisely to know metaphysical truth, (whence only can there be deduced and ascertained the governing principles of doing and making) that laws of conduct binding on the artist as a man can properly be promulgated. We cannot therefore expect from any legislative censorship an adjustment of the strained relations between the artist and the patron, producer and consumer ; the former is too much concerned with himself, the latter too unaware of man's real needs, whether physical or spiritual,—too much a lover of quantity and by far too little insistent upon the quality of life. The source of all our difficulties, whether economic, or psychic, lies beyond the power of legislation or philanthrophy ; what we require is a rectification of humanity itself and a consequent awareness of the priority of contemplation to action. We are altogether too ·busy, and have made a vice of industry.

Under present circumstances, then, art is by and large a luxury : a luxury that few can afford, and one that need not be overmuch lamented by those who cannot afford to buy. This same " art " was once the principle of knowledge by which the means of life were produced, and the physical and spiritual needs of man were provided for. The whole man made by contemplation, and in making did not depart from himself. To resume all that has been said in a single statement,— Art *is* a superstition : art *was* a way of life.

POSTSCRIPT

Note on Review by Richard Florsheim
of
IS ART A SUPERSTITION OR A WAY OF LIFE ?

IN reviewing my " Is Art a Superstition or a Way of Life ? " Mr. Florsheim assumes my " advocacy of a return to a more or less feudal order . . . an earlier, but dead, order of things." In much the same way a reviewer of " Patron and Artist " (cf. in *Apollo*, February, 1938, p. 100) admits that what I say " is all very true," but assumes that the remedy we " Mediævalists " (meaning such as Gill, Gleizes, Carey and me) suggest is to " somehow get back to an earlier social organization."

These false, facile assumptions enable the critic to evade the challenge of our criticism, which has two main points : (1) that the current " appreciation " of ancient or exotic arts in terms of our own very special and historically provincial view of art amounts to a sort of hocus pocus, and (2) that under the conditions of manufacture taken for granted in current artistic doctrine man is given stones for bread. These propositions are either true or not, and cannot honestly be twisted to mean that we want to put back the hands of the clock.

Neither is it true that we " do not pretend to offer much in the way of practical remedy " ; on the contrary, we offer everything, that is to " somehow get back to first principles." Translated from metaphysical into religious terms this means " Seek first

the kingdom of God and His Righteousness, and all these things shall be added unto you." What this can have to do with a sociological archaism or eclecticism I fail to see.

A return to first principles would not recreate the outward aspects of the Middle Ages, though it might enable us to better understand these aspects. I have nowhere said that I wished to " return to the Middle Ages." In the pamphlet reviewed I said that a cathedral was no more beautiful in kind than a telephone booth in kind, and expressly excluded questions of preference, i.e., of " wishful thinking." What I understand by " wishful thinking " is that kind of faith in " progress " which leads Mr. Florsheim to identify " earlier " with " dead," a type of thinking that ignores all distinction of essence from accident and seems to suggest a Marxist or at any rate a definitely anti-traditional bias.

Things that were true in the Middle Ages are still true, apart from any questions of styles ; suppose it eternally true, for example, that " beauty has to do with cognition." Does it follow from this that in order to be consistent I must decorate my house with crockets ? or am I forbidden to admire an aeroplane ? Dr. Wackernagel, reviewed in *The Art Bulletin*, XX, p. 123, " warns against the lack of purpose in most of our modern art." Need this imply a nostalgia for the Middle Ages on his part ? If I assert that a manufacture by art is humanely speaking superior to an " industry without art," it does not follow that I envisage knights in armour. If I see that manufacture for use is better for the consumer (and we are all consumers) than a manufacture for profit, this does not mean that we are to manufacture antiques. If I accept that vocation is the natural basis of individual progress (the word has a real meaning in an individual application, the meaning namely of *werden was du bist*),

I am not necessarily wrong merely because this position was " earlier " maintained by Plato and in the Bhagavad Gita. I do not in fact pretend to foresee the style of a future Utopia ; however little may be the value I attach to "modern civilisation," however much higher may have been the prevalent values of the mediæval or any other early or still existing social order, I do not think of any of these as providing a ready-made blueprint for future imitation. I have no use for pseudo-Gothic in any sense of the word. The sooner my critics realise this, and that I am not out to express any views, opinions or philosophy of my " own," the sooner will they find out what I am talking about.

IV

WHAT IS THE USE OF ART ANYWAY?*

WE are familiar with two contemporary schools of thought about art. We have on the one hand a very small self-styled élite which distinguishes "fine" art from art as skilled manufacture, and values this fine art very highly as a self-revelation or self-expression of the artist ; this élite, accordingly, bases its teaching of æsthetic upon style, and makes the so-called "appreciation of art" a matter of the manner rather than of the content or true intention of the work. These are our Professors of Æsthetics and of the History of Art, who rejoice in the unintelligibility of art at the same time that they explain it psychologically, substituting the study of the man himself for the study of the man's art ; and these leaders of the blind are gladly followed by a majority of modern artists, who are naturally flattered by the importance attached to personal genius.

On the other hand we have the great body of plain men who are not really interested in artistic personalities, and for whom art as defined above is a peculiarity rather than necessity of life, and have in fact no use for art.

And over against these two classes we have a normal but forgotten view of art, which affirms that art is the making well, or properly arranging, of anything whatever that needs to be made or arranged, whether a statuette, or automobile, or garden. In the Western world, this is specifically the Catholic doctrine of art ; from which doctrine the natural conclusion follows, in the words of St. Thomas, that "There can be no good use

* Originally two Broadcasts.

without art." It is rather obvious that if things required for use, whether an intellectual or a physical use, or under normal conditions both, are not properly made, they cannot be enjoyed, meaning by "enjoyed" something more than merely "liked." Badly prepared food for example, will disagree with us ; and in the .same way autobiographical or other sentimental exhibits necessarily weaken the morale of those who feed upon them. The healthy patron is no more interested in the artist's personality than he is in his tailor's private life : all that he needs of either is that they be in possession of their art.

The present series of talks about art is addressed to the second kind of man above defined, viz., to the plain and practically-minded man who has no use for art, as art is expounded by the psychologists and practised by most contemporary artists, especially painters. The plain man has no use for art unless he knows what it is about, or what it is for. And so far, is perfectly right ; if it is not about something, and not for anything, it *has* no use. And furthermore, unless it is about something *Worth while*,—more worth while, for example, than the artist's precious personality,—and for something worth while to the patron and consumer as well as to the artist and maker, it has no *real* use, but is only a luxury product or mere ornament. On these grounds art may be dismissed by a religious man as mere vanity, by the practical man as an expensive superfluity, and by the class thinker as part and parcel of the whole bourgeoisie fantasy. There are thus two opposite points of view, of which one asserts that there can be no good use without art, the other that art is a superfluity. Observe, however, that these contrary statements are affirmed with respect to two very different things, which are not the same merely because both have been called "art." Let us now take for granted the historically

normal and religiously orthodox view that, just as ethics is the " right way of doing things," so art is the "making well of whatever needs making," or simply " the right way of making things " ; and still addressing ourselves to those for whom the arts of personality are superfluous, ask whether art is not after all a necessity.

A necessity is something that we cannot afford to do without, whatever its price. We cannot go into questions of price here, except to say that art need not be, and should not be expensive, except to the extent that costly materials are employed. It is at this point that the crucial question arises of manufacture for profit versus manufacture for use. It is because the idea of manufacture for profit is bound up with the currently accepted industrial sociology that things in general are not well made and therefore also not beautiful. It is the manufacturer's interest to produce what we like, or can be induced to like, regardless of whether or not it will agree with us ; like other modern artists, the manufacturer is expressing himself, and only serving our real needs to the extent that he *must* do so in order to be able to sell at all. Manufacturers and other artists alike resort to advertisement ; art is abundantly advertised in schools and colleges, by " Museums of Modern Art," and by art dealers ; and artist and manufacturer both alike price their wares according to what the traffic will bear. Under these conditions as Mr. Carey, who speaks in this series of talks, has so well expressed it, the manufacturer works in order to be able to go on earning ; he does not earn, as he ought, in order to be able to go on manufacturing. It is only when the maker of things is a maker of things by vocation, and not merely holding down a job, that the price of things approximate to their real value ; and under these circumstances, when we pay for a work of art designed to serve a necessary purpose, we get our money's worth ; and

the purpose being a necessary one, we *must* be able to afford to pay for the art, or else are living below a normal human standard ; as most men are now living, even the rich, if we consider quality rather than quantity. Needless to add that the workman is also victimised by a manufacture for profit ; so that it has become a mockery to say to him that hours of work should be more enjoyable than hours of leisure ; that when at work he should be doing what he likes, and only when at leisure doing what he ought—workmanship being conditioned by art, and conduct by ethics.

Industry without art is brutality. Art is specifically human. None of those primitive peoples, past or present, whose culture we affect to despise and propose to amend, has dispensed with art ; from the stone age onwards, everything made by man, under whatever conditions of hardship or poverty, has been made by art to serve a double purpose, at once utilitarian and ideological. It is we who, collectively speaking at least, command amply sufficient resources, and who do not shrink from wasting these resources, who have first proposed to make a division of art, one sort to be barely utilitarian, the other luxurious, and altogether omitting what was once the highest function of art, to express and to communicate ideas. It is long since sculpture was thought of as the poor man's 'book." Our very word " æsthetics," from " æsthesis," " feeling," proclaims our dismissal of the intellectual values of art.

Two other points can only be touched upon in the time available. In the first place, if we called the plain man right in wanting to know what a work is about, and in demanding intelligibility in works of art, he is no less certainly wrong in demanding likeness and altogether wrong in judging works of ancient art from any such point of view as is implied in the common expressions, " That was before they knew anything about

anatomy," or "That was before perspective had been discovered." Art is concerned with the nature of things, and only incidentally, if at all, with their appearance ; by which appearance the nature of things is far more obscured than revealed. It is not the artist's business to be fond of nature as effect, but to take account of nature as the cause of effects. Art, in other words, is far more nearly related to algebra than to arithmetic and just as certain qualifications are needed if we are to understand and enjoy a mathematical formula, so the spectator must have been educated as he ought if he is to understand and enjoy the forms of communicative art. This is most of all the case if the spectator is to understand and enjoy works of art which are written, so to speak, in a foreign or forgotten language ; which applies to a majority of objects exhibited in our museums.

This problem presents itself because it is not the business of a museum to exhibit contemporary works. The modern artist's ambition to be represented in a museum is his vanity, and betrays a complete misunderstanding of the function of art ; for if a work has been made to meet a given and specific need, it can only be effective in the environment for which it was designed, that is to say in some such vital context as a man's house in which he lives, or in a street, or in a church, and not in any place the primary function of which is to contain all sorts of art.

The function of an art museum is to preserve from destruction and to give access to such ancient works of art as are still considered, by experts responsible for their selection, to be very good of their kind. Can these works of art, which were not made to meet his particular needs, be of any use to the plain man ? Probably not of much use at first sight and without guidance, nor until he knows what they are about and what they were for. We could rather wish, although in vain, that

the man in the street had access to such markets as those in which the museum objects were originally bought and sold at reasonable prices in the every-day course of life. On the other hand, the museum objects were made to meet specific human needs, if not precisely our current needs ; and it is most desirable to realize that there have been human needs other than, and perhaps more significant than, our own. The museum objects cannot indeed be thought of as shapes to be imitated, just because they were not made to suit our special needs ; but insofar as they are good of their kind, as is presupposed by the expert selection, there can be deduced from them, when considered in relation to their original use, the general principles of art according to which things *can* be well made, for whatever purpose they may be required. And that is broadly speaking, the major value of our museums.

Some have answered the question " What is the use of art " ? by saying that art is for art's sake ; and it is rather odd that those who thus maintain that art has no human use should at the same time have emphasized the value of art. We shall try to analyse the fallacies involved.

We referred above to the class thinker who has no use for art, and is ready to dispense with it as being part and parcel of the whole bourgeoisie fantasy. If we could discover such a thinker, we should indeed be glad to agree with him that the whole doctrine of art for art's sake, and the whole business of " collecting " and the " love of art " are no more than a sentimental aberration and means of escape from the serious business of life. We should be very ready to agree that merely to cultivate the higher things of life, if art be such, in hours of leisure to be obtained by a further substitution of mechanical for manual means of production, is as much a vanity as the cultivation of religion for religion's

sake on Sundays only could ever be ; and that the pretensions of the modern artist are fundamentally wishful and egotistic.

Unfortunately, when we come down to the facts, we find that the social reformer is not really superior to the current delusion of culture, but only angered by an economic situation which seems to deprive him of those higher things of life which the wealthy can more easily afford. The workman envies, far more than he sees through, the collector and " lover of art." The wage-slave's notion of art is no more realistic or practical than a millionaire's : just as his notion of virtue is no more realistic than that of the preacher of goodness for goodness' sake. He does not see that if we need art only if and because we *like* art, and ought to be good only if and because we *like* to be good, art and ethics are made out to be mere matters of taste, and no objection can be raised if we say that we have no use for art because we do not like it, or no reason to be good, because we prefer to be bad.

The subject of art for art's sake was taken up the other day by an Editor of the *Nation*, who quoted with approval a pronouncement by Paul Valery to the effect that the most essential characteristic of art is *uselessness*, and proceeded to say that " No one is shocked by the statement that ' Virtue is its own reward ' . . . which is only another way of saying that virtue, like art, is an end in itself, a final good." The writer also pointed out that "Uselessness and valuelessness are not the same things " ; by which, of course, he meant, " are not the same thing." He said further that there are only three motives by which an artist is impelled to work, viz., either " for money, fame, or ' art.' "

We need not look farther for a perfect example of the class thinker stupefied by what we have called the whole bourgeoisie fantasy. To begin with, it is very far from

95

true that no one is shocked by the statement that " Virtue is its own reward." If that were true, then virtue would be no more than the self-righteousness of the *uncó guid*. That " Virtue is its own reward " is actually in direct opposition to all orthodox teaching, where it is constantly and explicitly affirmed that virtue is a means to an end, and not itself an end ; a means to man's last end of happiness, and not a part of that end. And in just the same way in all normal and humane civilisations the doctrine about art has been that art is in the same way a means, and not a final end.

For example, the Aristotelian doctrine that " the general end of art is man " was firmly endorsed by the mediæval Christian encyclopædists ; and we may say that all those philosophical and religious systems of thought from which the class thinker would most like to be emancipated are agreed that both ethics and art are means to happiness, and neither a final end. The bourgeoisie point of view to which the social reformer in point of fact assents is sentimental and idealistic ; while the religious doctrine which he repudiates is utilitarian and practical ! In any case, the fact that a man takes pleasure, or may take pleasure, in doing well or in making well, does not suffice to make of this pleasure the purpose of his work, except in the case of the man who is self-righteous or that of the man who is merely a self-expressionist : just as the pleasure of eating cannot be called the final end of eating, except in the case of the glutton who lives to eat.

If use and value are not in fact synonymous, it is only because use implies efficacy, and value may be attached to something inefficient. Augustine, for example, points out that beauty is not just what we like, because some people like deformities ; or in other words, value what is really invalid. Use and value are not identical in logic, but in the case of a perfectly healthy subject, coincide

in experience ; and this is admirably illustrated by the etymological equivalence of German *brauchen* " to use " and Latin *frui* " to enjoy."

Nor can money, fame, or " art " be called explanations of art. Not money, because aside from the case of manufacture for profit instead of for use, the artist by nature, whose end in view is the good of the work to be done, is not working in order to earn, but earning in order to be able to go on being himself, viz., to be able to go on working as that which he is by nature ; just as he eats to be able to go on living, rather than lives to be able to go on eating. As to fame, it need only be pointed out that the greater part of the greatest art of the world has been produced anonymously, and that if any workman has only fame in view, " any proper man ought to be ashamed for good people to know this of him." And as to art, to say that the artist works for art is an abuse of language. Art is that *by* which a man works, supposing that he is in possession of his art and has the habit of his art ; just as prudence or conscience is that by which he acts well. Art is no more the end of his work than prudence the end of his conduct.

It is only because under the conditions established in a system of production for profit rather than for use we have forgotten the meaning of the word " vocation," and think only in terms of " jobs," that such confusions as these are possible. The man who has a " job " is working for ulterior motives, and may be quite indifferent to the quality of the product, for which he is not responsible ; all that he wants in this case is to secure an adequate share of the expected profits. But one whose vocation is specific, that is to say who is naturally and constitutionally adapted to and trained in some one or another kind of making, even though he earns his living by this making, is really doing what he likes most ; and if he is forced by circumstances to do some other kind

of work, even though more highly paid, is actually un-
happy. The vocation, whether it be that of the farmer
or the architect, is a function ; the exercise of this function
as regards the man himself is the most indispensable
means of spiritual development, and as regards his re-
lation to society the measure of his worth. It is precisely
in this way that as Plato says, " more will be done, and
better done, and with more ease, when everyone does
but one thing, according to his genius ; and this is
justice to each man in himself." It is the tragedy of a
society industrially organised for profit that this justice
to each man in himself is denied him ; and any such
society literally and inevitably plays the Devil with the
rest of the world.

The basic error in what we have called the illusion
of culture is the assumption that art is something to be
done by a special kind of man, and particularly that kind
of man whom we call a genius. In direct opposition
to this is the normal and humane view that art is simply
the right way of making things, whether symphonies
or aeroplanes. The normal view assumes, in other
words, not that the artist is a special kind of man, but
that every man who is not a mere idler and parasite is
necessarily some special kind of artist, skilled and well
contented in the making or arranging of some one thing
or another according to his constitution and training.

Works of genius are of very little use to humanity,
which invariably and inevitably misunderstands, distorts,
and caricatures their mannerisms and ignores their
essence. It is not the genius, but the man who can
produce a masterpiece, that matters. For what is a
masterpiece ? Not as commonly supposed an individual
flight of the imagination, beyond the common reach
in its own time and place and rather for posterity than
for ourselves ; but by definition, a piece of work done
by an apprentice at the close of his apprenticeship and

by which he proves his right to be admitted into the full membership of a guild, or as we should now say trade union, as a master workman. The masterpiece is simply the proof of competence expected and demanded from every graduate artist, who is not permitted to set up a workshop of his own unless he has produced such proof. The man whose masterpiece has thus been accepted by a body of practising experts is expected to go on producing works of like quality for the rest of his life ; he is a man responsible for everything he makes. The whole thing lies in the normal course of events, and so far from thinking of masterpieces as merely ancient works preserved in museums, the adult workman ought to be ashamed if anything he makes falls short of the masterpiece standard or is less than fit to be exhibited in a museum.

Genius inhabits a world of its own. The master craftsman lives in a world inhabited by other men ; he has neighbours. A nation is not " musical " because of the great orchestras that are maintained in its capitals, and supported by a select circle of " music-lovers," nor even because such orchestras offer popular programmes. England was a " nest of singing birds " when Pepys could insist on an under parlour-maid's ability to take a difficult part in the family chorus, failing which she would not be engaged. And if the folksongs of a country are now collected between the covers of books, or as the singer himself expresses it " put in a bag," or if in the same way we think of art as something to be seen in a museum, it is not that something has been *gained*, but that we know that something has been *lost*, and would fain preserve its memory.

There are, then, possibilities of " culture " other than those envisaged by our universities and great philanthropists, and possibilities of accomplishment other than those that can be displayed in drawing-rooms.

We do not deny that the class thinker may be perfectly justified in his resentment of economic exploitation ; as to this it will suffice to point out once and for all that " the labourer is worthy of his hire." But what the class thinker, as a man, and not merely in his obvious rôle of exploitee, ought to demand but hardly ever dares to demand is a human responsibility for whatever he makes. What the trade union should require of its members is a master's accomplishment. What the class thinker who is not merely an underdog, but also a man, has a right to demand is, neither to have less work to do, nor to be engaged in a different kind of work, nor to have a larger share in the cultural crumbs that fall from the rich man's table, but the opportunity to take as great a pleasure in doing whatever he does for hire, as he takes in his own garden or family life ; what he should demand, in other words, is the opportunity to be an artist. No civilisation can be accepted that denies him this.

With or without machines, it is certain that work will always have to be done. We have tried to show that while work is a necessity, it is by no means a necessary evil, but in case the workman is a responsible artist, a necessary good. We have spoken so far from the workman's point of view, but it need hardly be added that as much depends on the patron as upon the artist. The workman becomes a patron as soon as he proceeds to buy for his own use. And to him as consumer we suggest that the man who, when he needs a suit, does not buy two ready made suits of shoddy material, but commissions a skilled tailor to make one suit of fine material, is a far better patron of art and better philanthropist than the man who merely acquires an old master and gives it to the nation. The metaphysician and philosopher are also involved ; it should be a primary function of the Professor of Æsthetics to break down

the superstition of " Art," and that of the " Artist " as a privileged person, of another sort than ordinary men.

What the exploitee should resent is not merely the fact of social insecurity, but the position of human irresponsibility that is forced upon him under conditions of manufacture for profit. He has to realise that the question of the ownership of the means of production is primarily of spiritual significance, and only secondarily a matter of economic justice or injustice. In so far as the class thinker proposes to live by bread alone, or even with cake, he is neither better nor wiser than the bourgeoisie capitalist whom he affects to despise ; nor would he be any happier at work by an exchange of many masters for few. It makes but little difference whether he proposes to do without art, or to get his share of it, so long as he consents to the inhuman deification of " Art " implied in the expression " Art for art's sake." It is no more conducive to man's last, and present, end of happiness that he should sacrifice himself on the altar of " Art," than for him to sacrifice himself on the altars of a personified Science, State, or Nation.

On behalf of every man we deny that art is for art's sake. On the contrary, " Industry without art is brutality " ; and to become a brute is to die as a man. It is a matter of cannon fodder in either case ; it makes but little difference whether one dies in the trenches suddenly or in a factory day by day.

CHAPTER V

BEAUTY AND TRUTH

Ex divina pulchritudine esse omnium derivatur
(St. Thomas Aquinas, *De Pulchto*)

IT is affirmed that "beauty relates to the cognitive faculty" (St. Thomas Aquinas, *Sum. Theol.*, I, 5, 4 *ad.* 1) being the cause of knowledge, for, "since knowledge is by assimilation, and similitude is with respect to form, beauty properly belongs to the nature of a formal cause" (*ib.*). Again, St. Thomas endorses the definition of beauty as a cause, in *Sum. Theol.*, III, 88, 3, he says that "God is the cause of all things by his knowledge" and this again emphasizes the connection of beauty with wisdom. "It is knowledge that makes the work beautiful" (St. Bonaventura, *De reductione artium ad theologiam*, 13). It is of course, by its quality of lucidity or illumination (*claritas*), which Ulrich of Strassburg explains as the "shining of the formal light upon what is formed or proportioned," that beauty is identified with intelligibility : brilliance of expression being unthinkable apart from perspicacity. Vagueness of any sort, as being a privation of due form is necessarily a defect of beauty. Hence it is that in mediæval rhetoric so much stress is laid on the communicative nature of art, which must be always explicit.

It is precisely this communicative character that distinguished Christian from late classical art, in which style is pursued for its own sake, and content valued only as a point of departure ; and in the same way, from the greater part of modern art, which endeavours to eliminate

subject (*gravitas*). Augustine made a clean break with sophism, which he defines as follows : " Even though not quibbling, a speech seeking verbal ornament (Skr. *alaṁkāra*) beyond the bounds of responsibility to its burden (*gravitas*) is called sophistic " (*De doctrina christiana*, II, 31). Augustine's own rhetoric " goes back over centuries of the lore of personal triumph to the ancient idea of moving men to truth " (Baldwin, *Mediæval Rhetoric and Poetic*, p. 51), to Plato's position when he asks : " About what does the sophist make a man more eloquent ? " (*Protagoras*, 312), and Aristotle's, whose theory of rhetoric was one of the " energising of knowledge, the bringing of truth to bear upon men. Rhetoric is conceived by Aristotle as the art of giving effectiveness to truth ; it is conceived by the earlier and the later sophists as the art of giving effectiveness as to the speaker " (Baldwin, *loc. cit.*, p. 3). We must not think of this as having an application only to oratory or literature ; what is said applies to any art, as Plato makes explicit in the *Gorgias*, 503, where again he deals with the problem of what is to be said—" the good man, who is intent on the best when he speaks . . . is just like any other craftsman. . . . You have only to look, for example, at the painters, the builders. . . ." The scholastic position is, then, as remote from the modern as it is from the late classic : for just as in sophism, so in the greater part of modern art, the intention is either to please others or to express oneself. Whereas the art of pleasing, or as Plato calls it, " flattery " (*Gorgias*), is not for the Middle Ages the purpose of art, but an accessory (and for great minds not even an indispensable) means, so that as Augustine says, " I am not now treating of how to please ; I am speaking of how they are to be taught who desire instruction " (*ib.*, IV, 10). And whereas in the greater part of modern art one cannot fail to recognise an

exhibitionism in which the artist rather exploits himself than demonstrates a truth, and modern individualism frankly justifies this self-expressionism, the mediæval artist is characteristically anonymous and of " unobtrusive demeanour," and it is not who speaks, but what is said that matters.

No distinction can be drawn between the principles of mediæval plastic and figurative art and symbolic " ornament " and those of contemporary " sermons " and " tracts," of which an indication may be cited in the designation " Biblia pauperum " as applied to a pictorial relation of scriptural themes. As Professor Morey remarks, "The cathedral . . . is as much an exposition of mediæval Christianity as the *Summa* of Thomas Aquinas " (*Christian Art*, 1935, p. 49) ; and Baldwin, " The cathedrals still exhibit in sculpture and glass what came in words from their pulpits. . . . Such preaching shows the same preoccupations as the symbolic windows of the cathedrals, their carved capitals, above all the thronged but harmonized groups of their great porches " (*Mediæval Rhetoric and Poetic*, pp. 239, 244). It is therefore entirely pertinent to note that according to Augustine, who may be said to have defined once for all the principles of Christian art (*De doctrina christiana*, book IV, a treatise that " has historical significance out of all proportion to its size," Baldwin, *op. cit.*, p. 51), the business of Christian eloquence is " to teach, in order to instruct ; to please, in order to hold ; and also, assuredly, to move, in order to convince " (IV, 12-13) ; the formula *docere, delectare, flectere,* or alternatively *probare, delectare, movere,* deriving from Cicero ; *probare* means the demonstration of *quod est probandum,* the theme or burden of the work.[1] The meaning of " pleasure " (*delectatio*) is explained by St. Augustine when he says " one is pleasing (*gratus*) when he clears up matters that need to be made understood " (IV, 25).

But in the present context Augustine is thinking rather of pleasure given by "charm of diction" (*suavitas dictionis*) by means of which the truth to be communicated is at it were made palatable by the addition of a "seasoning" which, for the sake of weak minds, ought not to be neglected but is not essential if we are considering only those who are so eager for the truth that they care not how inelegantly (*inculte*) it may have been expressed, since "it is the fine characteristic of great minds (*bonorum ingeniorum*) that they love the truth that is in the words, rather than the words themselves" (IV, 11). And with reference to what we should call, perhaps, the severity of "primitive" art, Augustine's words are very pertinent : "O eloquence, so much the more terrible as it is so unadorned ; and as it is so genuine, so much the more powerful : O truly, an axe hewing the rock ! " (IV, 14).

Perspicacity is the first consideration ; such language must therefore be used as will be intelligible to those who are addressed. If necessary, even "correctness" (*integritas*)[2] of expression may be sacrificed, if the matter itself can be taught and understood "correctly" (*integre*) thereby (IV, 10). In other words, the syntax and vocabulary are for the sake of the demonstration (*evidentia : quod ostendere intendit*), and not the theme for the sake of the style (as modern æstheticians appear to believe). The argument is directed against a mechanical adhesion to a pedantic or academic "accuracy," and arises in connection with the problem of addressing a somewhat uncultivated audience. It amounts to this, that in actual teaching, one should employ the vernacular of those who are taught, provided that this is for the good of the thing to be taught, or as the *Laṅkâvatāra Sūtra*, II, 114, expresses it, "the doctrine is communicated only indirectly by means of the picture : and whatever is not adapted to such and

such persons as are to be taught, cannot be called teaching." The end is not to be confused with the means, nor are those good means which may seem to be good in themselves, but those which are good in the given application. It is of the greatest interest to observe that these principles amount to a recognition and sanction of such "distortions" or "departures from academic perfection" as are represented by what are called "architectural refinements." In the case of *entasis*, for example, the end in view is probably that the column may be understood to be perpendicular and straight-sided, the desired result being obtained by an actual divergence from straight-sidedness. At the same time, the accommodation is not made for æsthetic but for intellectual reasons ; it is in this way that the "idea" of perpendicularity is best communicated, and if the resulting "effect" is also visually satisfying, this is rather a matter of grace than the immediate purpose of the modification. In the same way with the composition of any work, this composition is determined by the logic of the theme to be communicated, and not for the comfort of the eye, and if the eye is satisfied, it is because a physical order in the organ of perception corresponds to the rational order present in whatever is intelligible, and not because the work of art was for the sake of the eye or ear alone. Another way in which "correctness," in this case "archæological accuracy," can properly be sacrificed to the higher end of intelligibility can be cited in the customary mediæval treatment of Biblical themes as if they had been enacted in the actual environment of those who depicted them, and with consequent anachronism. It hardly needs to be pointed out that a treatment which represents a mystical event as if a current event communicates its theme not less but more vividly, and in this sense more "correctly," than one which by a pedantic regard for archæological precision rather

separates the event from the spectator's " now " and makes it a thing of the past.

Augustine's principles are nowhere better exemplified than in the case of the *Divina Commedia*, which we now persist in regarding as an example of " poetry " or *belles-lettres*, notwithstanding that Dante says of it himself that " the whole work was undertaken not for a speculative but a practical end . . . the purpose of the whole is to remove those who are living in this life from the state of wretchedness, and to lead them to the state of blessedness " (*Ep. ad Can. Grand.*, §§ 16 and 15). Current criticism similarly misinterprets the Rig Veda, insisting on its "lyrical" qualities, although those who are in and of, and not merely students of, the Vedic tradition are well assured of the primarily injunctive function of its verses, and have regard not so much to their artistry as to their truth, which is the source of their moving power. The same confusions are repeated in our conceptions of " decorative art " and the " history of ornament." It is tacitly ignored that all that we call ornament or decoration in ancient and mediæval and, it may be added, in folk art, had originally, and for the most part still has there, an altogether other value than that which we impute to it when we nowadays plagiarize its forms in what is really " interior decoration " and nothing more ; and this we call a scientific approach !

In Europe, the now despised doctrine of a necessary intelligibility reappears at a comparatively late date in a musical connection. Not only had Josquin des Prés in the fifteenth century argued that music must not only sound well but mean something, but it is about this very point that the struggle between plainsong and counterpoint centred in the sixteenth century. The Church demanded that the words of the Mass should be " clearly distinguishable through the web of counterpoint which embroidered the plainsong." Record is preserved of a

bishop of Ruremonde " who states that after giving the closest attention he had been unable to distinguish one word sung by the choir " (Z. K. Pyne, *Palestrina, his Life and Times*, London, 1922, pp. 31 and 48). It was only when the popes and the Council of Trent had been convinced by the work of Palestrina that the new and more intricate musical forms were not actually incompatible with lucidity, that the position of the figured music was made secure.

Bearing in mind what has already been said on the invariably occasional character of art, together with what has been cited as to intelligibility, it is sufficiently evident that from a Christian point of view, the work of art is always a means, and never an end in itself. Being a means, it is ordered to a given end, without which it has no *raison d'être*, and can only be treated as bric-a-brac. The current approach may be compared to that of a traveller who, when he finds a signpost, proceeds to admire its elegance, to ask who made it, and finally cuts it down and decides to use it as a mantelpiece ornament. That may be all very well, but can hardly be called an understanding of the work ; for unless the end be apparent to ourselves, as it was to the artist, how can we pretend to have understood, or how can we judge his operation ?

If indeed we divert the work of art to some other than its original use, then, in the first place, its beauty will be correspondingly diminished, for, as St. Thomas says above, " if they are applied to another use or end, their harmony and therefore their beauty is no longer maintained," and, in the second place, even though we may derive a certain pleasure from the work that has been torn out of its context, to rest in this pleasure will be a sin in terms of Augustine's definitions " to enjoy what we should use " (*De Trinitate*, X, 10), or a " madness," as he elsewhere calls the view that art has no other

function than to please (*De doc. christ.*, IV, 14). The sin, insofar as it has to do with conduct and ignores the ultimate function of the work, which is to convince and instigate (*movere*), is one of luxury ; but since we are here concerned rather with æsthetic than with moral default, let us say in order to avoid the exclusively moralistic implications now almost inseparable from the idea of sin, that to be content only with the pleasure that can be derived from a work of art without respect to its context or significance will be an æsthetic solecism, and that it is thus that the æsthete and the art " depart from the order to the end." Whereas, " if the spectator could enter into these images, approaching them on the fiery chariot (Skr. *jyotiratha*) of contemplative thought (Skr. *dhyāna*, *dhī*) . . . then would he arise from the grave, then would he meet the Lord in the air, and then he would be happy " (Blake), which is more than to be merely pleased.

NOTES

[1] St. Bonaventura *De reductione artium ad theologiam*, (17, 18), *ad exprimendum, ad erudiendum at ad movendem*, " to express, instruct and persuade," viz., to express by means of a likeness, to instruct by a clear light, and to persuade by means of power." It may be noted that " clear light " is *lumen arguens*, and that our word " argument " is etymologically and originally " clarification " or " making bright."

[2] St. Augustine's *locutionis integritas* corresponds to Cicero's *sermonis integritas* (*Brut.* 35. 132) and means " correctness of expression." Similarly in St. Thomas, *Sum. Theol.*, I. 39. 8 *integritas sive perfection*, as a necessary condition of beauty, *integritas* is " accuracy " rather than " integrity " or " integration." Bearing in mind that all expression is by means of some likeness, what this means is " adequate symbolism," i.e., correctness of the iconography. We too often overlook that in speech just as much as in the visual arts, expression is by means of *images*.

CHAPTER VI

THE NATURE OF MEDIÆVAL ART

*Art is the imitation of Nature in her manner of operation :
Art is the principle of manufacture.*—St. Thomas Aquinas.

THE modern mind is as far removed from the ways
of thinking that find expression in Mediæval art
as it is from those expressed in Oriental art. We look
at these arts from two points of view, neither of them
valid : either the popular view that believes in a " pro-
gress " or " evolution " of art and can only say of a
" primitive " that " That was before they knew anything
about anatomy " or of " savage " art that it is " untrue
to nature " ; or the sophisticated view which finds in
the æsthetic surfaces and the relations of parts the whole
meaning and purpose of the work, and is interested only
in our emotional reactions to these surfaces.

As to the first, we need only say that the realism of later
Renaissance and academic art is just what the Mediæval
philosopher had in mind when he spoke of those " who
can think of nothing nobler than bodies," i.e., who
know nothing but anatomy. As to the sophisticated
view, which very rightly rejects the criterion of likeness,
and rates the " primitives " very highly, we overlook
that it also takes for granted a conception of " art "
as the expression of emotion, and a term " æsthetics "
(literally, " theory of sense-perception and emotional
reactions "), a conception and a term that have come into
use only within the last two hundred years of humanism.
We do not realise that in considering Mediæval (or
Ancient or Oriental) art from these angles, we are attri-
buting our own feelings to men whose view of art was

quite a different one, men who held that " Art has to do with cognition " and apart from knowledge amounts to nothing, men who could say that " the educated understand the rationale of art, the uneducated knowing only what they like," men for whom art was not an end, but a means to present ends of use and enjoyment and to the final end of beatitude equated with the vision of God whose essence is the cause of beauty in all things. This must not be misunderstood to mean that Mediæval art was " unfelt " or should not evoke an emotion, especially of that sort that we speak of as admiration or wonder. On the contrary, it was the business of this art not only to " teach," but also to " move, in order to convince " : and no eloquence can move unless the speaker himself has been moved. But whereas we make an æsthetic emotion the first and final end of art, Mediæval man was moved far more by the meaning that illuminated the forms than by these forms themselves : just as the mathematician who is excited by an elegant formula is excited, not by its appearance, but by its economy. For the Middle Ages, nothing could be understood that had not been experienced, or loved : a point of view far removed from our supposedly objective science of art and from the mere knowledge about art that is commonly imparted to the student.

Art, from the Mediæval point of view, was a kind of knowledge in accordance with which the artist imagined the form or design of the work to be done, and by which he reproduced this form in the required or available material. The product was not called " art," but an " artefact," a thing " made by art " ; the art remains in the artist. Nor was there any distinction of " fine " from " applied " or " pure " from " decorative " art. All art was for " good use " and " adapted to condition." Art could be applied either to noble or to common uses, but was no more or less art in the one case than

in the other. Our use of the word " decorative "
would have been abusive, as if we spoke of a mere
millinery or upholstery : for all the words purporting
decoration in many languages, Mediæval Latin included,
referred originally not to anything that could be added
to an already finished and effective product merely to
please the eye or ear, but to the completion of anything
with whatever might be necessary to its functioning,
whether with respect to the mind or the body : a
sword, for example, would " ornament " a knight, as
virtue " ornaments " the soul or knowledge the mind.

Perfection, rather than beauty, was the end in view.
There was no " æsthetic," no " psychology " of art,
but only a rhetoric, or theory of beauty, which beauty
was regarded as the attractive power of perfection in
kind and as depending upon propriety, upon the order
or harmony of the parts (some would say that this
implied, dependent upon certain ideal mathematical
relations of parts) and upon clarity or illumination—
the trace of what St. Bonaventura calls " the light of
a mechanical art." Nothing unintelligible could have
been thought of as beautiful. Ugliness was the un-
attractiveness of informality and disorder.

The artist was not a special kind of man, but every
man a special kind of artist. It was not for him to say
what should be made, except in the special case in
which he is his own patron making, let us say, an icon
or a house for himself. It was for the patron to say
what should be made ; for the artist, the " maker
by art," to know how to make. The artist did not
think of his art as a " self-expression," nor was the
patron interested in his personality or biography. The
artist was usually, and unless by accident, anonymous,
signing his work, if at all, only by way of guarantee :
it was not who, but what was said, that mattered. A
copyright could not have been conceived where it was

well understood that there can be no property in ideas, which are his who entertains them : whoever thus makes an idea his own is working originally, bringing forth from an immediate source within himself, regardless of how many times the same idea may have been expressed by others before or around him.

Nor was the patron a special kind of man, but simply our " consumer." This patron was " the judge of art " : not a critic or connoisseur in our academic sense, but one who knew his needs, as a carpenter knows what tools he must have from the smith, and who could distinguish adequate from inadequate workmanship, as the modern consumer cannot. He expected a product that would work, and not some private *jeu d'esprit* on the artist's part. Our connoisseurs whose interest is primarily in the artist's personality as expressed in style—the accident and not the essence of art—pretend to the judgment of Mediæval art without consideration of its reasons, and ignore the iconography in which these reasons are clearly reflected. But who can judge whether anything has been *well* said or made, and so distinguish good from bad as judged by art, unless he be fully aware of *what* was to be said or done ?

The Christian symbolism of which Emile Mâle spoke as a " calculus " was not the private language of any individual, century, or nation, but a universal language, universally intelligible. It was not even privately Christian or European. If art has been properly called a universal language, it is not such because all men's sensitive faculties enable them to recognize what they see, so that they can say, " This represents a man," regardless of whether the work has been done by a Scotchman or a Chinaman, but because of the universality of the adequate symbolism in which its meanings have been expressed. But that there is a universally intelligible language of art no more

means that we can all read it than the fact that Latin was spoken in the Middle Ages throughout Europe means that Europeans can speak it to-day. The language of art is one that we must relearn, if we wish to understand Mediæval art, and not merely to record our reactions to it. And this is our last word : that to understand Mediæval art needs more than a modern " course in the appreciation of art " : it demands an understanding of the spirit of the Middle Ages, the spirit of Christianity itself, and in the last analysis the spirit of what has been well named the " Philosophia Perennis " or " Universal and Unanimous Tradition," of which St. Augustine spoke as a " Wisdom, that was not made, but is now what it always was and ever shall be " ; some touch of which will open doors to the understanding of and a delight in any traditional art, whether it be that of the Middle Ages, that of the East, or that of the " folk " in any part of the world.

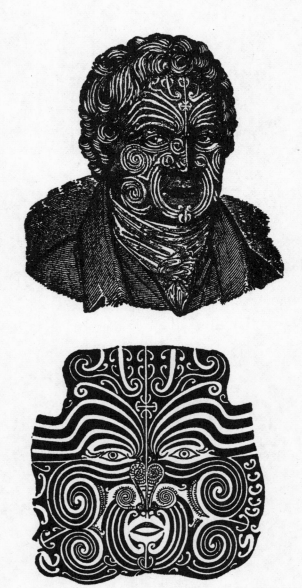

Two portraits of the Maori chieftain, Tupa Kupa :
above, by an English artist ; below, by himself.
After Frobenius, *The Childhood of Man*, 1909, p. 35.

VII

THE TRADITIONAL CONCEPTION OF IDEAL PORTRAITURE

THE Indian *Śukranītisāra* (IV.4.76) praises the making of divine images in accordance with canonical prescription, and condemns the portrayal of human likenesses as " not heaven-ward leading." The well known Cambodian and Javanese practise of erecting statues of deified ancestors in the likeness of divine images is in perfect agreement with this pronouncement. It can readily be inferred from the text of the *Pratimānataka* (III.5), where Bharata, visiting an ancestral chapel, is unable to recognize the effigies of his own parents, at the same time that he exclaims at the perfection of the workmanship and feels the moving power of the figures, that here too in India proper it must have been rather the deified man than the man as he had been on earth that was represented in the effigies.[1] There are still extant, moreover, numerous later Indian votive bronze statuettes, which are specifically " portraits " of such and such a donor, and yet cannot be distinguished, or scarcely distinguished, from divine images ; as well as others in which the intention to represent a human being is evident, but the facial expression is altogether that of a type, without individual peculiarities. On the other hand, in the dramatic literature, there is an abundance of detailed references to a secular art of portraiture in which a real likeness to the living subject was essential to the social, and largely erotic, purpose of the work.

It is quite evident, then, that in India we have to take account of two quite different kinds of portraiture,

respectively posthumous, hieratic, and ideal on the one hand, and taken from life, profane, and sentimental on the other. We shall find that there existed in Europe also a corresponding tradition of ideal portraiture, of which full account must be taken if we are to understand the underlying significance of facial expression in mediæval Christian art. Before going on to the European sources, however, we shall refer to two other Indian texts in which a distinction is drawn between the appearance of the man on the one hand, and on the other the interior image of the very man invisible to the physical eye but accessible to the eye of contemplation. The relation between the outward appearance and the interior image is analogous to that between the æsthetic surfaces of an actual painting and " the picture that is not in colours " (*Lankâvatâra Sūtra*, II.112-114).

A distinction between the looking-glass image and the veritable spiritual-essence of the man is sharply drawn in the *Chāndogya Upaniṣad* VIII.8.5, where the question is posed of the nature of the spiritual-essence, or very Self (*ātman*), in a dialogue between the Progenitor, the Angel Indra and the Titan Virocana. The Progenitor asks the two latter to adorn themselves as best they can, and to consider their reflection in a bowl of water. " What do you see ? " " We see ourselves just as we are, with all our adornments," they reply. " That is the spiritual-essence (*ātman*), that is the immortal, that is God," he tells them, meaning that what they see is a form in the image and likeness of deity.[2] Indra and Virocana, however, understand that the outward aspect and the spiritual-essence of the man are one and the same thing, and they go away satisfied with this nothing-more-ish (*nâstika*) conclusion.[3] The Progenitor watches them as they go, and remarks " They have gone away without understanding, without having known the very Self. Whoever has such an

understanding as theirs, whether Angel or Titan, must perish." Indra, however, is not finally satisfied, and returns for further instruction ; he finally learns that this body (i.e., body with sensitive consciousness, or "soul") is mortal and in the power of death, but that it is the "standing-ground" of the immortal spiritual-essence (*ātman*), the veritable knowing subject. It is, in fact, the whole burden of the Upaniṣads and Bhagavad Gītā to distinguish in this way the Spirit from the body-and-soul, the Knower of the Field from the field itself ; just as also in Christianity, "The word of God is quick and powerful, and sharper than any two-edged sword, extending even unto the sundering of soul from spirit" (Heb. IV. 12).

In the *Uttaratantra* of Maitreya, 88-91 there is a Parable of the Painters, illustrating what is meant by the realisation of the whole transcendent person of the Buddha (the whole painting) by means of a trans-formative constitution of all its parts (the various members of the painted representation) : it is, then, a question of ideal portraiture and the likeness of a "mystical body." There can be little doubt, indeed, that the reference in stanza 89 is to the occasion on which, as related in the *Divyâvadāna*, Ch. XXXVII, Rudrâyaṇa desires a portrait of the Buddha, and summons his court painters, who, however, are unable to "grasp" the Buddha's likeness; and the Buddha then projects his "outline" or "shadow" on the canvas, instructing the painters to fill it in with colours. We cite now the *Uttaratantra* passage from Obermiller's version in *Acta Orientalia*, Vol. IX, pp. 208-209 :

88. Suppose there were some painters,
Skilful (in painting) various (parts of the body),
And each of them, knowing his own special member,
Would not be able (to paint) the rest.

89. (Suppose then) a mighty king would bid to them—
 On this (cloth) ye all must draw my portrait,—
 And hand the cloth to them with this com-
 mandment.
 And (the painters) having heard (his word),
 Would start their work of painting.

90. (Suppose again), of these painters engaged in the
 work,
 One should go abroad and, owing to his absence,
 Their number being incomplete, the portrait
 Could not be accomplished in all its parts.

91. The painters who are meant here
 Are Charity, Morals, Patience, and the rest,
 And that which is the highest point of excellence,
 The essence of all relative entities—this is the
 picture.

"The picture," viz., "that is not in the colours," to
repeat our citation from the *Lankâvatâra Sûtra*.

We are now in a position to consider the European
parallels. The fundamental distinction between the
outward appearance and inward reality of the enlightened,
and in this case specifically initiated Hermes (who is
really no more than the Buddha or Christ in the last
analysis merely this or that man but the Universal Man
and *forma humanitatis*) is made in the *Corpus Hermeticum*,
lib. XIII (Scott, *Hermetica*, I.241) ; in a dialogue
between Hermes and his son Asclepius, who is himself
about to be, but has not yet been, "born again," Hermes
denies that Asclepius, who is actually looking at his
father, can really see him. He says :

"I see that by God's mercy there has come to be in
me a form which is not fashioned out of matter. . . .
I am not now the man I was ; I have been born again
in Mind (νοῦς = Skr. *manas*), and the bodily shape
which was mine before has been put away from me.

I am no longer an object coloured and tangible ; a thing of spatial dimensions ; I am now alien to all this, and to all that you perceive when you gaze with bodily eyesight. To such eyes as yours, my son, *I* am not now visible."[4]

The whole point of view is similar to that of the Chāndogya Upaniṣad cited above, where in the same way a sharp distinction is made between the spiritually essential *person* and the empirical *ego* : and it is significant that the as yet unregenerated Asclepius (like Bharata in the *Pratimānāṭaka*) fails to recognize his own father in this spiritual image of which he speaks.

Porphyry tells us that Plotinus refused to allow his portrait to be made, objecting : " Is it not enough to carry about this image in which nature has enclosed us ? Do you really think I must also consent to leave, as a desirable spectacle to posterity, an image of the image ? "[5]

When now in John XIV. 9 Christ says, " He that hath seen Me, hath seen the Father," it is very evident that in the same way "Me" does not mean the outward and physically visible and tangible man Jesus whom all men could see with their bodily eyes, but rather that spiritual essence of which he speaks when he also says, " I and my Father are one."

We come next to a long but very significant passage in the Apocryphal *Acts of John*, 26-29 (M. R. James, *The Apocryphal New Testament*, ed. 1926, pp. 232-234). Here Lycomedes, who has just been raised from the dead by the mediation of John, summons his friend, a skilful painter, that he may " possess him (John) in a portrait." Unknown to John, the painter makes an outline, and on the next day filling it in with colours, presents the portrait to Lycomedes, who " set it up in his own bedchamber and hung it with garlands," and spent much time with it. John now, who has never seen himself in a mirror, goes into the chamber and sees there " the portrait of an

old man crowned with garlands, and lamps and altars set before it." He asks what all this means : " Can it be one of thy gods that is painted here ? for I see that thou art still living in heathen fashion." Lycomedes answers, " My only God is he who raised me up from death with my wife : but if, next to that God, it is right that men who have benefited us should be called gods— it is thou, father, whom I have had painted in that portrait, whom I crown and love and reverence as having become my good guide." Then Lycomedes brings him a mirror :

" And when he had seen himself in the mirror and looked earnestly at the portrait, he said : As the Lord Jesus Christ liveth, the portrait is like me : yet not like me, child, but like my fleshly image ; for if this painter, who hath imitated this my face, desireth to draw (the very) *me* in a portrait, he will be at a loss (needing more than) the colours that are now given to thee, and boards and plaster (?) and glue (?), and the position of my shape, and old age and youth and all things that are seen with the eye.

" But do thou become for me a good painter, Lycomedes. Thou hast colours which he giveth thee through me, who painteth all of us for himself, even Jesus, who knoweth the shapes and appearances and postures and dispositions and types of our souls. And the colours wherewith I bid thee paint are these : faith in God, knowledge, godly fear, friendship, communion, meekness, kindness, brotherly love, purity, simplicity, tranquillity, fearlessness, griefless-ness, sobriety, and the whole band of colours that painteth the likeness of thy soul, and even now raiseth up thy members that were cast down, and levelleth them that were lifted up, and tendeth thy bruises, and healeth thy wounds, and ordereth thine hair that was disarranged, and washeth thy face, and chasteneth

thine eyes, and purgeth thy bowels, and emptieth thy belly, and cutteth off that which is beneath it ; and in a word, when the whole company and mingling of such colours is come together, into thy soul, it shall present it to our Lord Jesus Christ undaunted, whole,[6] and firm of shape. But this that thou has now done is childish and imperfect : thou hast drawn a dead likeness of the dead."

It is unmistakably the same point of view that we find again in Eckhart, who remarks that " Any face thrown on a mirror is, willy-nilly, imaged therein. But its nature does not appear in the looking-glass image : only the mouth, nose and eyes, just the features, are seen in the mirror" (Evans ed. I. 51),[7] and again, " My looks are not my nature, they are the accidents of nature. . . . To find nature herself all her likenesses have to be shattered and the further in the nearer the actual things " (*ib.* I. 94 and 259) ; " According to philosophers, to make a portrait of a man one must not copy Conrad nor yet Henry. For if it be like Conrad or like Henry it will not recall the man, but will remind one of Conrad or Henry . . . given the knowledge and the art, one could do Conrad to the life, the very image of him. Now God both will and can : he made thee like unto himself, the very image of himself " (*ib.* 128) : " If I paint my likeness on the wall, he who sees the likeness is not seeing me ; but anyone who sees *me* sees my likeness and not my likeness merely but my child "[8] (*ib.* 408) ; for " the more and the more clearly God's image shows in man the more evidently God is born in him. And by God's eternal birth in him we understand that his image stands fully revealed " (*ib.* 157). Nor is this merely a matter of human representation : " The most trivial thing perceived in God, a flower for example as espied in God, would be a thing more perfect than the universe " (*ib.* 206) : " any flea as it is in God

is nobler than the highest of the angels in himself "
(*ib.* 240). And finally, " Creatures all come into my
mind and are rational in me. I alone prepare all creatures
to return to God . . . I alone take all creatures out of their
sense and make them one in me " (*ib.* 143),—that is
to say in that human nature that has nothing to do with
time.

" Intellect's substance is essence, not accident " (*ib.*
17) : " will enjoys things as they are in themselves,
whereas intellect enjoys them as they are in it " (*ib.* 394) ;
" the intellect is higher than the will " (*ib.* 213). In
the face of this tradition of an ideal portrayal (ideal, of
course, in the philosophical sense, that of Augustine
when he says that it is by their ideas that we judge of
what things ought to be like) can we wonder at the
intellectual and impersonal character of Oriental and
mediæval Christian art, in which the form is all important,
and the figuration irrelevant ? If Jitta-Zadoks says of the
tomb effigies of the twelfth century that " These statues
first represented the deceased not as he actually appeared
at death (nor, we may add, as he actually appeared in
life) but as he hoped and trusted to be on the day of
Judgment.⁹ This . . . is apparent in the pure and happy
expression of all the equally youthful faces which have
lost every trace of individuality " (*Ancestral Portraiture
in Rome*, 1932, p. 92) : if the Crucifixion, appearing in
Christian art soon after the fourth century, had been at
first and throughout the ages of faith an eminent symbol
of the triumph over death, in which " les yeux sont
ouverts et l'attitude ne trahit aucune expression de
douleur," and the figure is really that of a crowned King
" gardant sur l'instrument de son supplice toute la
majesté d'un Dieu " (Bréhier, *L'Art Chrétien*, 1928,
pp. 81, 335) : and if on the other hand from the thir-
teenth century onwards it was less and less " how the
dead would perhaps appear one day but how they had

actually appeared in life (that) was considered important. More or less likeness was now wanted (and) . . . as the last consequence of this demand for exact likeness the death mask, taken from the actual features, made its appearance " (Jitta-Zadoks, *loc. cit.* pp. 92 f.) ; if " Dès la fin du XIII⁰ siècle . . . l'art cherche moins à instruire qu'à mouvoir par le developpement qu'il donne aux épisodes les plus douloureux de la Passion . . . le Christ n'ouvre plus les yeux ; il est mort sur la croix ; son corps décharné, dont on aperçoit les os, n'est plus retenu que par les deux bras . . . la tête tombe tristement sur la poitrine. C'est au début du XIII⁰ siècle que cette vision tragique apparait sur des peintures italiennes et, bien que l'ancienne figure du Christ vivant sur la croix se soit conservée encore quelque temps, elle a fini par céder le pas à la nouvelle création. . . . Ou voit quelle distance sépare ce Christ humanisé des figures nobles et sereines qu'avaient conçues les artistes français du XIII⁰ siècle " (Bréhier, *loc. cit.* pp. 10, 336, 328) ; if the same thing can be recognized in the contemporary conversion of epic to romance, and generally in a reversal of the doctrine of the superiority of contemplation to action, and in a turning away from experience to experimentation ; if the form is now conquered by the figure, the intellect subordinated to the will, if the likeness of the dead now takes the place of the image of the living principle, this extroversion and declension of the European consciousness (for which no parallel can be adduced in Asia before the nineteenth century) implies the triumph of another kind of man who could not, in fact, to quote the prescient and bitter words of St. Thomas, " think of anything nobler than bodies " (*Sum. Theol.* I. 1. 9),—*our* kind of man. Whereas it had been regarded as the splendour of truth that it "extended even to the sundering of soul from spirit " (Heb. IV. 12), and the proper man had been required to " hate his own soul "

(Luke, XIV. 26), and taught that man's perfection depended upon a "last death of the soul" (Eckhart, Ruysbroeck), man had *now* embarked upon the way that was to lead him to—psychology and spiritualism, and the fetishistic worship of "aesthetic surfaces."

It is not our present intention to speak of the Truth : our current disciplines are interested less in Truth than in what opinions men have entertained at various times, less interested in the Philosophia Perennis than in the "history of philosophy." We shall only remark that the common expression according to which it is said that with the Renaissance interest shifted from the future to a present life[10] is a misleading half-truth ; the larger truth is that interest shifted from an inner presence to an outer present, from the spiritual essence of the very Man to the accidents of his sensitive outer ego, and that whereas it had been held that the very Man was literally capable of all things,[11] the stature of this man was now to be reduced to that of a refined and sensitive animal, whose behaviourism should depend, like that of any other animal, on a merely estimative knowledge. It is the former Man, the God, that was to be represented in the ideal portrait envisaged by tradition ; the latter and animal-man that is represented in our art.

The impersonality and serenity of mediæval Christian and Asiatic art, its facies, so to speak, are precisely what such texts as we have cited might have led us to expect. We cannot pretend really to have understood such arts as these, merely from the provincial standpoint of our own humanism. The mediæval and Asiatic artists did not observe ; they were required to be what they would represent, whether in motion or at rest. How can we propose to ourselves to judge these arts from a point of view connected historically with the use of death masks and nowadays with the posed model and the study of nature as still life (" nature morte ") ? It would be

idle to attempt to bridge the gulf between our art and that of mediæval Europe and of Asia by the postulation of a common interest in " art," just as it would be idle to attempt to bridge the gulf between our own and Christian or Asiatic religion by the postulation of a common interest in ethics.

Iconography is the constant essence, style the variable accident of art. All traditional art can be reduced to theology,[12] or is, in other words, dispositive to a reception of truth, by original intention ; its symbolism, in the phrase of Émile Mâle " a calculus," is the technical language of a quest. To repeat these formulæ merely as art forms without reference is to substitute a mimicry for a mimesis ; to repeat them merely for their vaguely emotive values puts them into a category with the " blessed word, Mesopotamia," to which most of our inherited " design " has long since been relegated. We cannot be said really to have known these forms by a merely formal analysis and apart from a knowledge of their application, which implies an environment both physical and psychic. Works of traditional art are, as we said, bound up with a technique of pursuit ; and as Mallinowski has very pertinently expressed it, " Technical language, in matters of practical pursuit, acquires a meaning only through personal participation in this type of pursuit." The patron, as Plato held, is the true judge of art ; we can only understand to the extent that we are able to identify ourselves with the Mediæval and Asiatic patron and artist in whom the final and the formal causes of the work subsisted, and whose knowledge was therefore, not as ours is, derivative and accidental, but essential and original.

WHY EXHIBIT WORKS OF ART ?

NOTES

[1] Dr. Quaritch Wales observes that " the statues of the Bangkok kings [18th–19th century) . . . are true portrait statues : but this is an innovation of the Bangkok period, indeed, the first three kings never allowed themselves to be portrayed " : also " with the speed of education . . . the substitution, gradual but inevitable, of respect for the Man in place of respect for Divine Kingship : the attitude of mind in which respect is offered to the memory of dead kings will tend to approximate more and more to that of other advanced nations " (*Siamese State Ceremonies*, 1931, p. 170).

Here, in the words " education " and " advanced " there lies an irony of which the author seems to have been unconscious !

[2] The Progenitor's answer may be compared to the Buddha's when he says " He who sees the Word sees Me " (*Sam. Nikāya*, III. 120), and Christ's when he says that " He who sees Me, sees the Father " (John XIV. 9), where it is not meant in either case that what is actually and physically heard or seen is the " Me " or the " Father " intended.

[3] The same image recurs in *Bṛhadāraṇyaka Upaniṣad*, II. 2. 8-9 : the ignorant Doctor Gārgya worships the person reflected in the water or in a mirror, i.e., his own person, and is corrected by the gnostic Ajātaśatru who says that he worships the Person *in* a likeness and as the Refulgent, who is the archetype of the image, not as seen in physical waters or mirrors, but in the heart. For *nāstika* see H.J.A.S. IV. 149 f., s.v. *natthika*. The " nothing-morists " are " those who think that nothing is except what they can grasp firmly with their hands " (Plato, *Theatetus* 155 E) : as against those who hold with *Ṛgveda*, X. 31. 8, *naitāvad enā, paro anyad asti*, " there is not merely this, but a transcendent other."

[4] In the same way, neither men nor gods can see the Buddha as he really is (*Saṁyutta Nikāya*, I. 23) : those who see or hear him physically do not really see or hear him at all (*Vajracchedika Sutra*, XXVI). " I live, yet not I (Paul), but Christ in me " (Gal. II. 20) ; " He has died to self, and come to life through the Lord ; hence the mysteries of God are on his lips " (Rūmī, *Mathnawī*, III. 3364).

[5] Cf. *Enneads*, VI. 2. 21 ; and Plato's expression, " copies of copies " (*Republic*, 601). From the same point of view Austerius, Bishop of Amasea, *ca.* A.D. 340, " Paint not Christ : for the one humility of his incarnation suffices him, which for our sake he voluntarily accepted " (Migne, *Pat. Gr.*, XI. 67).

[6] The editor adds within brackets : " unsmoothed." The meaning may be that the living portrait will not be, like the picture, something that has been flattened out, as it were.

[7] Cf. Plato, *Alcibiades*, I. 130 E, οὐ πρὸς τὸ σὸν πρόσωπον ἀλλὰ πρὸς τὸν ᾿Αλκιβιάδη ν, and Rūmī, *Mathnawī*, I. 1020-1, " The picture on the wall is a likeness of Adam, indeed ; but see what in that glorious shape is lacking,—the Spirit." This man, So-and-so (*yoyam āyasmā evaṁnāmo evaṁgotto*, S. III) is not the Man, him-Self.

[8] " The body, like a mother, is big with the spirit-child : death is the pangs and throes of birth. . . . *I* (my Self) am cramped like an embryo in the womb ; I have come to be nine months old ; this migration has become urgent " (Rūmī, *Mathnawī*, I. 3514, III. 3556).

[9] Whereas it can be said of Renaissance tomb-effigies that " Princes' images do not lie, as they were wont, seeming to pray to Heaven ; . . . they are not carved with their eyes upon the stars, but as their minds were wholly bent upon the world, the selfsame way they seem to turn their faces " (from *The Duchess of Malfi*).

[10] It is not without interest to observe a reflection of this point of view in our willingness to exhaust and destroy the material resources of the earth for the sake of *present* advantage and without regard to the needs of *future* generations.

[11] " Nothing shall be impossible to you" (Math. XVII. 20) : " Think that for you, too, nothing is impossible " (Hermes Trismegistus, *Lib.*, XI. 2. 20 B).

[12] " Reduced " does not, of course bear here its vernacular meaning of " diminished," but the etymological and technical value of " led back " as one leads back to or refers to its source what had been educed from it, as from that in which it subsists more eminently.

VIII

THE NATURE OF "FOLKLORE"
AND "POPULAR ART"

A SHARP distinction is commonly drawn between
" learning " and folklore, " high art " and popular
art ; and it is quite true that under present conditions
the distinction is valid and profound. Factual science
and personal or academic art on the one hand, and
" superstitition " and " peasant art " on the other
are indeed of different orders, and pertain to different
levels of reference.

We seem to find that a corresponding distinction
has been drawn in India between the constituted
(*saṁskṛta*) and provincial (*deśī*) languages and literatures,
and between a highway (*mārga*) and a local or byway
(*deśī*) art ; and what is *saṁskṛta* and *mārga* being
always superior to what is *deśī*, an apparent parallel is
offered to the modern valuation of learning and academic
art and relative disparagement of superstition and folk
art. When, for example, we find in *Saṁgītadarpaṇa*,
I. 4-6, " The ensemble of music (*saṁgītam*) is of two
kinds, highway (*mārga*) and local (*deśī*) : that which
was followed after by Śiva (*druhinena*)[1] and practised
(*prayuktam*) by Bharata is called ' highway ' and bestows
liberation (*vimukti-dam*) ; but that which serves for
worldly entertainment (*lokânurañjakam*) in accordance
with custom (*deśasthayā-rityā*) is called 'local,'" and when
similarly the *Daśarūpa*, I. 15, distinguishes *mārga*
from *deśī* dancing, the first being " that which displays
the meanings of words by means of gestures,"[2] it is
generally assumed that the modern distinction of

" art " from " folk " music is intended. It is also true
that the modern *ustād* looks down upon what are actually
folk-songs, very much in the same way that the academic
musician of modern Europe looks down upon folk
music, although in neither case is there an entire want
of appreciation.

A pair of passages parallel to those above can advan-
tageously be cited. In the *Jaiminīya Brāhmaṇa*, II.
69-70, where Prajāpati and Death conduct opposing
sacrifices,[3] the protagonists are aided by two " armies "
or " parties," Prajāpati's consisting of the chanted lauds,
recitative, and ritual acts (the sacerdotal art), and
Death's of " what was sung to the harp, enacted
(*nṛtyate*),[4] or done, by way of mere entertainment "
(*vṛthā*). When Death has been overcome, he resorts
to the women's house (*patnīśālā*), and it is added that
what had been his " party " are now " what people
sing to the harp, or enact, or do, to please themselves "
(*vṛthā*). In the *Śukranītisāra*, IV. 4. 73-76, we find
that whereas the making of images of deities is " con-
ducive to the world of heavenly light," or " heavenward
leading " (*svargya*), the making of likenesses of men,
with however much skill, is " non-conducive to the
world of heavenly light " (*asvargya*). The common
reference of *vṛthā* (lit. " heretical " in the etymological
sense of this word) and *asvargya* here to what is connoted
by our word *deśī*, previously cited, will be evident.

A similar distinction of sacred from profane musical
art is drawn in *Śatapatha Brāhmaṇa*, III. 2. 4, in
connection with the seduction of Vāc, who is won
over from the Gandharvas by the Devas ; Vāc, the
feminine principle, turns away from the Vedic recita-
tions and the hymnody and lauds in which the Gan-
dharvas are occupied, and turns to the harp-playing
and singing with which the mundane Devas propose
to please her. It is significant that whereas the Gan-

dharvas invite her attention by saying, "We verily know, we know," what is offered by the gods is to "give you pleasure" (tvā pramodayiṣyāma). And so, as the text expresses it, Vāc indeed inclined to the gods, but she did so "vainly" (mogham), inasmuch as she turned away from those who were occupied with celebration and laudation, to the dancing and singing of the gods. And "This is why women even here and now (itarhi) are addicted to vanity (moghaṁ-saṁhitāḥ), for Vāc inclined thereto, and other women do as she did. And so it is that they take a liking most readily to one who sings and dances" (nṛtyati, gāyati).[5] It is quite clear that mogham here corresponds to vṛthā in the Jaiminīya text, and that in both cases the worldly and feminine arts of mere amusement are contrasted with the sacred liturgical arts. It is also perfectly clear that the worldly arts of mere amusement are regarded literally as "deadly"—it must not be forgotten that "all that is under the sun is under the sway of death" (mṛtyun-āptam, Śatapatha Br., X. 5. 1. 4)—and that such disparagement of the arts as can be recognized in Indian thought (especially Buddhist) from first to last is a disparagement not of the arts as such, but of the secular arts of mere amusement as distinguished from the intellectual arts that are a very means of enlightenment.[6]

Before going further it will be desirable to examine more closely some of the terms that have been cited. In connection with the passage quoted above, Dr. Bake has remarked that "The religious value of art music —mārga—is clearly apparent from this quotation, and actually this music, as conceived by the highest God and handed down through a succession of teachers, is felt as a means of breaking the cycle of birth." Apart from the questionable rendering of mārga by "art," this is absolutely true. The doctrine that human

works of art (*śilpāni*) are imitations of heavenly forms, and that by means of their rhythm there can be effected a metrical reconstitution (*saṁskaraṇa*) of the limited human personality, dates at least from the Brāhmana period (*Aitareya Brāhmaṇa*, VI. 27, etc.), and is implied in the Ṛgveda. "Sanskrit" itself is "constructed" (*saṁskṛtam*) in just this sense ; it is something more than merely "human" speech, and when the corresponding script is called *devanāgarī* this undoubtedly implies that the human script is an imitation of means of communication in the "city of the gods."

Since the Ṛgveda has to do only with what is incessant (*nityam*), it is evident that all its terms are symbols rather than signs, and must be understood in their transfigured senses. Now the word *mārga*, rendered above by "highway," derives from *mṛg*, to chase or hunt, especially by tracking.[7] In the Ṛgveda it is familiar that what one hunts and tracks by its spoor is always the deity, the hidden light, the occulted Sun or Agni, who must be found, and is sometimes referred to as lurking in his lair. This is so well known that a very few citations will suffice. In Rv. VIII. 2. 6 men are said to pursue (*mṛgayante*) Indra, as one pursues a wild beast (*mṛgaṁ na*), with offerings of milk and kine (which may be compared to bait) ; in Rv. VII. 87. 6, Varuṇa is compared to a "fierce beast" (*mṛgaś tuviṣmān*) ; in Rv. X. 46. 2 the Bhṛgus, eager seekers after Agni, track him by his spoor (*padaiḥ*) like some lost beast (*paśun na naṣṭam*). *Mārga* is then the creature's "runway," the "track to be followed" (*padavīya*) by the *vestigium pedis*. One sees thus clearly what values are implied in the expression *mārga*, "Way," and how inevitably that which is *mārga* is likewise *vimukti-da*, since it is precisely by the finding of the Hidden Light that liberation is effected.[8]

Deśī, on the other hand, deriving from *diś*, to

" indicate," and hence *diś*, " region " or " quarter,"
is " local " ; cf. *deśaṁ niviś*, to " settle " in a given
locality, *deśa vyavahāra* or *deśâcāra*, " local custom,"
" way of the world," and *deśya*, " native." But these
are not merely terms that could be derogatively employed
by city people or courtiers to countrymen in general,
but that could be employed by dwellers in the city of
God or in any Holy Land with reference to those beyond
the pale. Heaven lies " beyond the falcon," the worlds
are " under the sun," and " in the power of death " ;
loka " world," is etymologically Latin *locus*, a place
defined by given conditions ; and *laukika*, " mundane "
is literally " local " ; it is precisely here (*iha*) in the
worlds that the kindreds are " settled," " localized,"
and " native." From the celestial or solar point of
view, *deśī* is thus mundane, human and devious, as
distinct from super-mundane, divine and direct ; and
this distinction of *mārga* (= *svargya*) from *deśī* as sacred
from profane is in full agreement with the sense of the
expressions *rañjaka* (pleasing, impassioning, affecting, etc.)
and *vṛthā* (wanton, random, " as you like," etc.), by
which the value of *deśī* has been explained above.

If we now consider the terrestrial analogy, then,
looking at the matter from the Brahmans' point of view
(who are " gods on earth "), whatever is geographically
and—or qualitatively removed from an orthodox centre,
from a Holy Land (such as Aryāvarta) where the heavenly
pattern is accurately imitated, will be at the same time
geographically and spiritually " provincial " ; those are
pre-eminently *deśī* who are outer barbarians beyond the
pale ; and in this sense *deśī* is the equivalent of
" heathen " or " pagan " in the primary sense of
" pertaining to the heaths or wastes," as well as "pagan"
in the secondary sense of worldly or sentimental
(materialistic).

Highway and local or byway cultures can be pursued

at one and the same time and in one and the same environment ; they are not so much the cultures of ethnically different peoples or of given social strata as they are the cultures of qualitatively different kinds of people. The distinction is not nearly so much of aristocratic from peasant culture as it is one of aristocratic and peasant from bourgeoisie and proletarian cultures. Mughal painting, for example, even when more refined than Hindu painting, is a byway rather than a highway art ; it is essentially an art of portraiture (from the *mārga* point of view, then, *asvargya*), and a " dated " art, which is as much as to say a " placed " (*deśī*) art, for we cannot logically restrict the idea of " local " to a merely spatial significance, and indeed the two commonly associated words *kāla-deśa* imply one another. From the Indian point of view, then, it is not the " primitive " (but abstract) art of the American Indian, or the peasant cultures of Europe or India, but rather the anti-traditional, academic, and bourgeoisie culture of modern Europe, and the proletarian culture of Soviet Russia, that can properly be called a devious and " byway " culture, " not heavenward leading." A traditional must not be confused with an academic or merely fashionable art ; tradition is not a mere stylistic fixation, nor merely a matter of general suffrage. A traditional art has fixed ends and ascertained means of operation, has been transmitted in pupillary succession from an immemorial past, and retains its values even when, as at the present day, it has gone quite out of fashion. Hieratic and folk arts are both alike traditional (*smārta*). An academic art, on the other hand, however great its prestige, and however fashionable it may be, can very well be and is usually of an anti-traditional, personal, profane, and sentimental sort.

We think it has now been made sufficiently clear that the distinction of *mārga* from *deśī* is not necessarily

a distinction of aristocratic and cultivated from folk and primitive art, but one of sacred and traditional from profane and sentimental art.

We may then very well ask what is the true nature of folk and peasant art, and whether such an art differs from that of the *kavi* and *ācārya* in any other way than in degree of refinement. In traditional and unanimous societies we observe that no hard and fast line can be drawn between the arts that appeal to the peasant and those that appeal to the lord ; both live in what is essentially the same way, but on a different scale. The distinctions are of refinement and luxury, but not of content or style ; in other words, the differences are measurable in terms of material value, but are neither spiritual nor psychological. The attempt to distinguish aristocratic from popular motifs in traditional literature is fallacious ; all traditional art is a folk art in the sense that it is the art of a unanimous people (*jana*). As Professor Child has remarked in connection with the history of ballads, " The condition of society in which a truly national and popular poetry appears . . . (is one) in which the people are not divided by political organizations and book-culture into marked distinct classes[9] ; in which, consequently, there is such community of ideas and feelings that the whole people form one individual."

It is only because we regard these problems from the narrow standpoint of present circumstances that we fail to grasp this condition. In a democratic society, where all men are theoretically equal, what exists in fact is a distinction between a bourgeoisie culture on the one hand and the ignorance of the uncultured masses on the other, notwithstanding that both classes may be literate. Here there is no such thing as a " folk " (*jana*), for the proletariat is not a " folk," but comparable rather to the outcaste (*caṇḍāla*) than to a fourth

estate (śūdra) : the sacerdotal (brāhmaṇa) and chivalrous
(kṣatriya) classes are virtually lacking (men are so much
alike that these functions can be exercised by *anyone*
—the newsboy, for example, becoming a President) ;
and the bourgeoisie (vaiṣya) is assimilated to the prole-
tarian (caṇḍāla) masses, to form what is in effect an
unanimously profane " herd " (paśu) whose conduct
is governed only by likes and dislikes, and not by any
higher principles. ⁰ Here the distinction of "educated"
from " uneducated " is merely technical ; it is no
longer one of degrees of consciousness, but of more or
less information. Under these conditions the distinction
of literacy from illiteracy has a value altogether different
from its value in traditional societies in which the whole
folk, at the same time that it is culturally unanimous,
is functionally differentiated ; literacy, in the latter
case, being quite unnecessary to some functions, where,
moreover, its absence does not constitute a privation,
since other means than books exist for the communica-
tion and transmission of spiritual values ; and, further,
under these circumstances, the function itself (sva-
dharma), however " menial " or "commercial," is
strictly speaking a " way " (mārga), so that it is not by
engaging in other work to which a higher or lower
social prestige may attach, but to the extent that a
man approaches perfection in his own work and under-
stands its spiritual significance that he can *rise above
himself*—an ambition to *rise above his fellows* having
then no longer any real meaning.

In democratic societies, then, where proletarian and
profane (*i.e.*, ignorant) values prevail, there arises a
real distinction of what is optimistically called "learning"
or " science " on the part of the educated classes from
the ignorance of the masses ; and this distinction is
measured by standards, not of profundity, but of
literacy, in the simple sense of ability to read the printed

word. In case there survives any residue of a true peasantry (as is still the case in Europe, but scarcely in America), or when it is a question of the "primitive" culture of other races, or even of traditional scriptures and metaphysical traditions that are of anything but popular origin, the "superstitions" involved (we shall presently see what is really implied by this very apt term) are confounded with the "ignorance" of the masses, and studied only with a condescending lack of understanding. How perverse a situation is thus created can be seen when we realize that where the thread of symbolic and initiatory teaching has been broken at higher social levels (and modern education, whether in India or elsewhere, has precisely and very often intentionally, this destructive effect), it is just the "superstitions" of the people and what is apparently irrational in religious doctrine that has preserved what would otherwise have been lost. When the bourgeoisie culture of the universities has thus declined to levels of purely empirical and factual information, then it is precisely and only in the superstitions of the peasantry, wherever these have been strong enough to resist the subversive efforts of the educators, that there survives a genuinely human and often, indeed, a superhuman wisdom, however unconscious, and however fragmentary and naive may be the form in which it is expressed. There is, for example, a wisdom in traditional fairy tales (not, of course, in those which have been written by "literary" men "for children") that is altogether different in kind from such psychological sense or nonsense as may be embodied in a modern novel.

As has been justly remarked by M. René Guénon, "The very conception of 'folklore,' as commonly understood, rests on a fundamentally false hypothesis, the supposition, viz., that there really are such things as 'popular creations' or spontaneous inventions of

the masses ; and the connection of this point of view with the democratic prejudice is obvious. . . . The folk has thus preserved, without understanding, the remains of old traditions that go back sometimes to an indeterminably distant past, to which we can only refer as ' prehistoric.' '' What has really been preserved in folk and fairy tales and in popular peasant art is, then, by no means a body of merely childish or entertaining fables or of crude decorative art, but a series of what are really esoteric doctrines and symbols of anything but popular invention. One may say that it is in this way, when an intellectual decadence has taken place in higher circles, that this doctrinal material is preserved from one epoch to another, affording a glimmer of light in what may be called the dark night of the intellect; the folk memory serving the purpose of a sort of ark, in which the wisdom of a former age is carried over (*tiryate*) the period of the dissolution of cultures that takes place at the close of a cycle.[11]

It is not a question of whether or not the ultimate significance of the popular legends and folk designs is actually understood by those who relate or employ them. These problems arise in much higher circles ; in literary history, for example, one is often led to ask, when we find that an epic or romantic character has been imposed on purely mythical material (for example in the Mahābhārata and Rāmâyana, and in the European recensions of the Grail and other Celtic material), how far has the author really understood his material ? The point that we want to bring out is that the folk material, regardless of our actual qualifications in relation to it, is actually of an essentially *mārga* and not a *deśī* character, and actually intelligible at levels of reference that are far above and by no means inferior to those of our ordinary contemporary '' learning.'' It is not at all shocking that this material should have

been transmitted by peasants for whom it forms a part of their lives, a nourishment of their very constitution, but who cannot explain ; it is not at all shocking that the folk material can be described as a body of " superstition," since it is really a body of custom and belief that " stands over " (*superstat*) from a time when its meanings were understood. Had the folk beliefs not indeed been once understood, we could not now speak of them as metaphysically intelligible, or explain the accuracy of their formulation. The peasant may be unconscious and unaware, but that of which he is unconscious and unaware is in itself far superior to the empirical science and realistic art of the " educated " man, whose real ignorance is demonstrated by the fact that he studies and compares the data of folklore and " mythology " without suspecting their real significance any more than the most ignorant peasant.[12]

All that has been said above applies, of course, with even greater force to the *śruti* literature and, above all, the Rgveda, which so far from representing an intellectually barbarous age (as some pretend) has references so far abstract and remote from historical and empirical levels as to have become almost unintelligible to those whose intellectual capacities have been inhibited by what is nowadays called a " university education." It is a matter at the same time of faith and understanding: the injunctions *Crede ut intelligas* and *Intellige ut credas* ("Believe, that you may understand," and " Understand, in order to believe ") are valid in both cases—*i.e.*, whether we are concerned with the interpretation of folklore or with that of the transmitted texts.

NOTES

[1] Brahmā may be meant, but the word suggests rather Śiva Both of these aspects of deity are traditionally " authors " of the principles of music and dancing ; the former in the *Nāṭya Śāstra*, the latter in the *Abhinaya Darpaṇa*.

[2] The *Abhinaya Darpaṇa* similarly distinguishes *nṛtya*, or mimesis— viz., that form of the dance which has flavour, mood, and implied significance (*rasa, bhāva, vyañjana*)—from *nṛtta*, or decorative dancing, devoid of flavour and mood.

[3] It need hardly be pointed out that the Vedic sacrifice, constantly described as a mimesis of " what was done in the beginning," is in all its forms and in the fullest sense of the words a work of art, and a synthesis of arts liturgical and architectural, just as the same can be said of the Christian Mass (which is also a mimetic sacrifice), in which the dramatic and architectural elements are inseparably connected.

[4] It should not be supposed that it is only on Death's side that there is singing to the harp, enactment (*nṛt*), and a doing (*kṛ*) ; the point is that all of these acts are done by him *vṛthā*, " wantonly," for mere pleasure, and not in due form. As already remarked, the sacrifice is mimetic by nature and definition, and it is for this reason that we render *nṛtyate* by " enacted " rather than by " danced " ; for though there can be no doubt that the ritual, or portions of it, were in a certain sense " danced," (as " Indra danced his heroic deeds," RV. V. 33. 6), this expression would hardly convey to a modern reader the significance of the root *nṛt* as employed here as well as in later stage directions, where what is intended is a signification by means of formal and rhythmic gestures. That the ritual must have been, as we said, at least in parts, a kind of dance, is evident from the fact that the gods themselves, engaged in the work of creation, are compared to dancers (*nṛtyatām iva*, RV X. 72. 6), and that in KB. XVII. 8 the sacrificing priests are spoken of as " dancing " (*ninartyanti*), Keith justly commenting that this implies a " union of song, recitation, and dancing "—that is to say, what is later called the ensemble of music, *saṃgīta*. It may be added that ritual dancing survived in the Christian sacrifice at least as late as the eighteenth century in Spain.

The contests of Prajāpati with Death parallels that of Apollo with Marsyas, as to which Plato says that the man of sound mind will " prefer Apollo and his instruments to Marsyas and his " (*Republic* 399 E).

[5] Similarly but more briefly in the *Taittirīya Saṃhitā*, VI. VI. 1. 6. 5. 6, where also the Gandharvas who utter incantations are contrasted with the (mundane) deities who merely " sing," and Vāc follows the latter, but is restored to the former as the price of Soma. The mundane deities are, of course the immanent Breaths, the powers of the soul ; it is only when they restore the Voice to the Sacerdotium that they are enabled to partake of the Water of Life ; as in RV. X. 109. 5-7, where the (mundane) deities, restoring his wife (i.e., Vāc) to Bṛhaspati, obtain the Soma in exchange, and are made free of their original sin.

[6] The modern iconoclastic attitude towards the arts of imagery and dancing, according to which attempts are made to abolish " idolatry " and the service of Devadāsīs in temples, is of a deformative rather than a reformative nature. The intellectual limitations of the iconoclast are such that he interprets in a worldly and moralistic sense what are in

themselves by no means vain and deadly but truly *mārga* and *svargya* arts ; contemporary mentality reduces all things to its own *deśī* level.

[7] *Mṛga* is " deer," but in the Old English sense of " four-footed game," without necessary reference to the Cervidæ—a usage that survives in the expression " small deer." The relation of *mṛga*, animal, to *mṛg*, to hunt, may be compared to that of our " fowl " to " fowling."

[8] It may be noted that *pada* as a " word " or " phrase " is a naturally developed meaning, all formal language being a trace of the unspoken Word—" the lovely tokens (*lakṣmīḥ*) are inherent in the seers' speech," RV. X. 71. 2. In casual conversation, worldly speech, on the other hand, there is nothing more than a literal indication of perceptions, and only the estimative understanding is involved. This distinction in the verbal field corresponds to that of *mārga* from *deśī* dancing, the former having an intelligible theme and embodying more than literal meanings, as is implied by the word *vyañjana*. The one kind of communication is formal (ideally informed) and intellectual, the other informal and sensitive: " Were it not for Intellect, the Word would babble incoherently " (SB. III. 2. 4. 11). It is from this point of view, and only accidentally geographically, that Sanskrit is distinguished from the vernaculars (*deśī bhāṣā*), of which one may say that Apabhraṁśa is most of all a " byway " or " devious " and non-significant (*avyakta*) manner of communication, and that such as Braj Bhāṣā or Tamil are *deśī* in the geographical sense only. In the same way one may say that all sacred languages employed in the transmission of traditional doctrines are " highway," and that languages designed or employed for purely practical purposes (Esperanto would be a good example) are " byway " tongues. Pali, Nevertheless, by its confusion of certain words (e.g. *dīpa=dīpa* or *dvīpa*) is not *as* well fitted as Sanskrit for precise communications of ideas.

[9] It need hardly be pointed out that a caste or feudal organization of society is no more a division in this sense than is the complex organization of the physical body the mark of a disintegrated personality.

[10] A condition of the individual can be imagined that is superior to caste ; an absolute *pramāṇa*, for example, is predicated of deity, for whom no function (*dharma*) is too high or too low. The proletarian condition, on the other hand, is not of this nature, but *inferior* to caste, alike from a spiritual and from an economic point of view ; for as Plato has expressed it, " more will be done, and better done, and with more ease, when everyone does but one thing, according to his genius ; and this is justice to each man as he is in himself."

[11] Cf. Luc-Benoist, *La Cuisine des Anges*, 1932, pp. 74-75, " L'intérêt profond de toutes les traditions dites populaires réside surtout dans le fait qu'elles ne sont pas populaires d'origine. . . . Aristote y voyait avec raison les restes de l'ancienne philosophie. Il faudrait dire les formes anciennes de l'éternelle philosophie "—*i.e.*, of the *philosophia perennis*, Augustine's " Wisdom uncreate, the same now as it ever was and the same to be for evermore." As pointed out by Michelet, V.-E., it is in this sense—viz., inasmuch as " les Maîtres du Verbe projettent leurs inventions dans la mémoire populaire, qui est un réceptacle merveilleux des concepts merveilleux " (*Le Secret de la Chevalerie*, 1930, p. 19) —and not in any " democratic " sense, that it can properly be said, *Vox populi, vox Dei.*

The beast fables of the *Pañcatantra*, in which a more than merely worldly wisdom is embodied, is unquestionably of aristocratic and not of popular origin ; most of the stories in it have, as Edgerton says,

‘gone down” into Indian folklore, rather than been derived from it *Amer. Oriental Series*, III, 1924, pp. 3, 10, 54). The same applies, without question, to the *Jātakas*, many of which are versions of myths, nd could not possibly have been composed by anyone not in full command of the metaphysical doctrines involved.

Andrew Lang, introducing Marian Roalfe Cox's *Cinderella* (1893), in which 345 versions of the story from all over the world are analysed, remarked, “The fundamental idea of Cinderella, I suppose, is this : a person of mean or obscure position, by means of supernatural assistance, makes a good marriage.” He found it very difficult to account for the world-wide distribution of the motive ; of which, it may be added, there is a notable occurrence *in a scriptural context* in the Indian myth of Apālā and Indra. Here I will only ask the reader, of *what* “person in a mean or obscure position ” is the “ good marriage ” referred to in the words of Donne, “ Nor ever chaste until thou ravish me ? ” whom did Christ “ love in her baseness and all her foulness ” (St. Bonaventura, *Dom. prim. post Oct. Epiph.* II. 2) ? and what does the ἱερὸς γάμος imply in its final significance ? And by the same token, *who* is the “ dragon ” disenchanted by the *fier baiser* ? Who emerges with a “ sunskin ” from the scaly slough, who shakes off the ashes and puts on a golden gown to dance with the Prince ? *Pra vasīyāṇsam vivāham āpnoti ya evaṃ veda*, “ More excellent is the marriage that one makes who understands that ” (*Pañcaviṃśa Brāhmaṇa*, VII. 10. 4) !

[12] Strzygowksi, in *Jisoa.* V. p. 59 expresses his complete agreement with this statement.

BEAUTY OF MATHEMATICS : A REVIEW

EVERYONE knows that mathematicians some-
times speak of perfectly formulated equations
as " beautiful " and are excited by them as the con-
noisseur is excited by works of art. The present
volume will be of the greatest interest and value to
" æstheticians," since it is here for the first time that
the " beauty " of mathematics has been discussed by
a mathematician. Professor Hardy's analysis of this
beauty[1] is penetrating and illuminating, and in welcome
contrast to the vagueness that is so characteristic of
most modern writings on the criteria of beauty in
other kinds of art.

" A mathematician, like a painter or a poet, is a
maker of patterns. . . . The mathematician's patterns,
like the painter's or the poet's, must be *beautiful* ;
the ideas, like the colours or the words must fit together
in a harmonious way. Beauty is the first test : there
is no permanent place in the world for ugly mathematics "
(pp. 24, 25). " The best mathematics is *serious* as
well as beautiful. . . . The beauty of a mathematical
theorem *depends* a great deal on its seriousness. . . .
A ' serious ' theorem is a theorem that contains ' signi-
ficant ' ideas . . . (for which). . . . There are two
things at any rate that seem essential, a certain *generality*
and a certain *depth* " (pp. 29-43). By generality it is
meant " That the relations revealed by the proof
should be such as to connect many different mathema-
tical ideas . . . (not one of) the isolated curiosities in
which arithmetic abounds " (p. 44).[2] Depth " has
something to do with *difficulty* ; the deeper ideas are
usually the harder to grasp " (p. 49). In such beautiful

theorems as those propounded by Euclid and Pythagoras
" there is a very high degree of *unexpectedness*, com-
bined with *inevitability* and *economy* . . . the weapons
used seem so childishly simple compared with the
far-reaching results ; but there is no escape from the
conclusions " (p. 53). And thus Professor Hardy is
" interested in mathematics only as a creative art "
(p. 55).

Having so well defined what are in fact the essentials
in any art, the author, who seems to be acquainted
only with modern (" æsthetic ") conceptions of art,
naturally rates the beauty of mathematics above that of
" art." He quotes without protest Housman's " Poetry
is not the thing said but a way of saying it "—a pro-
nouncement fit to make Dante or Aśvaghoṣa turn in
their graves. He takes an example from Shakespeare :

> Not all the water in the rough rude sea
> Can wash the balm from an anointed King

and asks " Could lines be better, and could ideas be
at once more trite and more false ? The poverty of
the ideas seems hardly to affect the beauty of the verbal
pattern." What the example really proves is, not that
beauty can be independent of validity, but that beauty
and validity are relative. There is nothing made that
can be either beautiful or apt in all contexts. " Nothing
is beautiful for any other purpose than that for which
that thing is adapted " (Socrates in Xenophon, *Mem.* iv.
6, 9). The example also shows that no pronouncement
can be true except for those to whom its truth is apparent.
To any Platonist or other traditionalist, and to the
reviewer, Shakespeare's words are beautiful *and* true,
but they are not true for Professor Hardy or in any
democratic context. And where they are not true, the
mere fact that the sounds of the words is liked does
not make them beautiful in the sense of the tradition
that maintains that " Beauty pertains to cognition " :

but only " beautiful " (or rather, " lovely ") to those whom Plato calls " lovers of fine colours and sounds." Professor Hardy is not one of these ; he confesses ignorance of æsthetics, but all he needs to do is to apply his own mathematical standards of intelligibility and economy to other works of art, and let the Housmans say what they will. " Ideas do matter to the pattern " (p. 31).

As an " Apology," Professor Hardy's book is a defence of real or higher mathematics against those who raise objection to their uselessness (in the crude sense of the word). All he need have said is that mathematics as a whole serves needs both of the soul and of the body, like the arts of primitive man and those which Plato would have admitted to his Republic. That the higher mathematics have served his own soul well is shown by his concluding statement that, if he had a statue on a column in London, and were able to choose whether the column should be so high that the features of the statue would be invisible, or so low that they could be clearly seen, he would choose the first alternative (p. 93) ; and since it is man's first duty to work out his own salvation (from himself), no further defence is needed. He makes it perfectly clear that he could not have " done better " in any other field ; mathematics was his vocation. He was right to be a mathematician, not because he succeeded (p. 90), but rather, he succeeded because he did " what it was his to do, by nature," which is Plato's type of " justice " and in the *Bhagavad Gītā* the way that leads to perfection.

NOTES

[1] G. H. Hardy, *A Mathematician's Apology*, Cambridge University Press, 1941. Pp. 93.

[2] The bearing of this upon the notion of art as the record of an impression or effect is obvious. An art form can only be called " serious " when it subsumes many single instances. The Trundholm sun-wheel is serious, but a still life of a particular wagon wheel in a particular light is trivial. The Japanese are justified in not taking their *ukiyoye* " seriously."

A CATALOGUE OF SELECTED DOVER BOOKS
IN ALL FIELDS OF INTEREST

A CATALOGUE OF SELECTED DOVER BOOKS
IN ALL FIELDS OF INTEREST

AMERICA'S OLD MASTERS, James T. Flexner. Four men emerged unexpectedly from provincial 18th century America to leadership in European art: Benjamin West, J. S. Copley, C. R. Peale, Gilbert Stuart. Brilliant coverage of lives and contributions. Revised, 1967 edition. 69 plates. 365pp. of text.

21806-6 Paperbound $3.00

FIRST FLOWERS OF OUR WILDERNESS: AMERICAN PAINTING, THE COLONIAL PERIOD, James T. Flexner. Painters, and regional painting traditions from earliest Colonial times up to the emergence of Copley, West and Peale Sr., Foster, Gustavus Hesselius, Feke, John Smibert and many anonymous painters in the primitive manner. Engaging presentation, with 162 illustrations. xxii + 368pp.

22180-6 Paperbound $3.50

THE LIGHT OF DISTANT SKIES: AMERICAN PAINTING, 1760-1835, James T. Flexner. The great generation of early American painters goes to Europe to learn and to teach: West, Copley, Gilbert Stuart and others. Allston, Trumbull, Morse; also contemporary American painters—primitives, derivatives, academics—who remained in America. 102 illustrations. xiii + 306pp.

22179-2 Paperbound $3.50

A HISTORY OF THE RISE AND PROGRESS OF THE ARTS OF DESIGN IN THE UNITED STATES, William Dunlap. Much the richest mine of information on early American painters, sculptors, architects, engravers, miniaturists, etc. The only source of information for scores of artists, the major primary source for many others. Unabridged reprint of rare original 1834 edition, with new introduction by James T. Flexner, and 394 new illustrations. Edited by Rita Weiss. 6⅝ x 9⅝.

21695-0, 21696-9, 21697-7 Three volumes, Paperbound $15.00

EPOCHS OF CHINESE AND JAPANESE ART, Ernest F. Fenollosa. From primitive Chinese art to the 20th century, thorough history, explanation of every important art period and form, including Japanese woodcuts; main stress on China and Japan, but Tibet, Korea also included. Still unexcelled for its detailed, rich coverage of cultural background, aesthetic elements, diffusion studies, particularly of the historical period. 2nd, 1913 edition. 242 illustrations. lii + 439pp. of text.

20364-6, 20365-4 Two volumes, Paperbound $6.00

THE GENTLE ART OF MAKING ENEMIES, James A. M. Whistler. Greatest wit of his day deflates Oscar Wilde, Ruskin, Swinburne; strikes back at inane critics, exhibitions, art journalism; aesthetics of impressionist revolution in most striking form. Highly readable classic by great painter. Reproduction of edition designed by Whistler. Introduction by Alfred Werner. xxxvi + 334pp.

21875-9 Paperbound $3.00

A History of Costume, Carl Köhler. Definitive history, based on surviving pieces of clothing primarily, and paintings, statues, etc. secondarily. Highly readable text, supplemented by 594 illustrations of costumes of the ancient Mediterranean peoples, Greece and Rome, the Teutonic prehistoric period; costumes of the Middle Ages, Renaissance, Baroque, 18th and 19th centuries. Clear, measured patterns are provided for many clothing articles. Approach is practical throughout. Enlarged by Emma von Sichart. 464pp. 21030-8 Paperbound $3.50

Oriental Rugs, Antique and Modern, Walter A. Hawley. A complete and authoritative treatise on the Oriental rug—where they are made, by whom and how, designs and symbols, characteristics in detail of the six major groups, how to distinguish them and how to buy them. Detailed technical data is provided on periods, weaves, warps, wefts, textures, sides, ends and knots, although no technical background is required for an understanding. 11 color plates, 80 halftones, 4 maps. vi + 320pp. 6⅛ x 9⅛. 22366-3 Paperbound $5.00

Ten Books on Architecture, Vitruvius. By any standards the most important book on architecture ever written. Early Roman discussion of aesthetics of building, construction methods, orders, sites, and every other aspect of architecture has inspired, instructed architecture for about 2,000 years. Stands behind Palladio, Michelangelo, Bramante, Wren, countless others. Definitive Morris H. Morgan translation. 68 illustrations. xii + 331pp. 20645-9 Paperbound $3.00

The Four Books of Architecture, Andrea Palladio. Translated into every major Western European language in the two centuries following its publication in 1570, this has been one of the most influential books in the history of architecture. Complete reprint of the 1738 Isaac Ware edition. New introduction by Adolf Placzek, Columbia Univ. 216 plates. xxii + 110pp. of text. 9½ x 12¾. 21308-0 Clothbound $12.50

Sticks and Stones: A Study of American Architecture and Civilization, Lewis Mumford.One of the great classics of American cultural history. American architecture from the medieval-inspired earliest forms to the early 20th century; evolution of structure and style, and reciprocal influences on environment. 21 photographic illustrations. 238pp. 20202-X Paperbound $2.00

The American Builder's Companion, Asher Benjamin. The most widely used early 19th century architectural style and source book, for colonial up into Greek Revival periods. Extensive development of geometry of carpentering, construction of sashes, frames, doors, stairs; plans and elevations of domestic and other buildings. Hundreds of thousands of houses were built according to this book, now invaluable to historians, architects, restorers, etc. 1827 edition. 59 plates. 114pp. 7⅞ x 10¾. 22236-5 Paperbound $4.00

Dutch Houses in the Hudson Valley Before 1776, Helen Wilkinson Reynolds. The standard survey of the Dutch colonial house and outbuildings, with constructional features, decoration, and local history associated with individual homesteads. Introduction by Franklin D. Roosevelt. Map. 150 illustrations. 469pp. 6⅝ x 9¼. 21469-9 Paperbound $5.00

ADVENTURES OF AN AFRICAN SLAVER, Theodore Canot. Edited by Brantz Mayer. A detailed portrayal of slavery and the slave trade, 1820-1840. Canot, an established trader along the African coast, describes the slave economy of the African kingdoms, the treatment of captured negroes, the extensive journeys in the interior to gather slaves, slave revolts and their suppression, harems, bribes, and much more. Full and unabridged republication of 1854 edition. Introduction by Malcom Cowley. 16 illustrations. xvii + 448pp. 22456-2 Paperbound $3.50

MY BONDAGE AND MY FREEDOM, Frederick Douglass. Born and brought up in slavery, Douglass witnessed its horrors and experienced its cruelties, but went on to become one of the most outspoken forces in the American anti-slavery movement. Considered the best of his autobiographies, this book graphically describes the inhuman treatment of slaves, its effects on slave owners and slave families, and how Douglass's determination led him to a new life. Unaltered reprint of 1st (1855) edition. xxxii + 464pp. 22457-0 Paperbound $3.50

THE INDIANS' BOOK, recorded and edited by Natalie Curtis. Lore, music, narratives, dozens of drawings by Indians themselves from an authoritative and important survey of native culture among Plains, Southwestern, Lake and Pueblo Indians. Standard work in popular ethnomusicology. 149 songs in full notation. 23 drawings, 23 photos. xxxi + 584pp. 6⅝ x 9⅜. 21939-9 Paperbound $5.00

DICTIONARY OF AMERICAN PORTRAITS, edited by Hayward and Blanche Cirker. 4024 portraits of 4000 most important Americans, colonial days to 1905 (with a few important categories, like Presidents, to present). Pioneers, explorers, colonial figures, U. S. officials, politicians, writers, military and naval men, scientists, inventors, manufacturers, jurists, actors, historians, educators, notorious figures, Indian chiefs, etc. All authentic contemporary likenesses. The only work of its kind in existence; supplements all biographical sources for libraries. Indispensable to anyone working with American history. 8,000-item classified index, finding lists, other aids. xiv + 756pp. 9¼ x 12¾. 21823-6 Clothbound $30.00

TRITTON'S GUIDE TO BETTER WINE AND BEER MAKING FOR BEGINNERS, S. M. Tritton. All you need to know to make family-sized quantities of over 100 types of grape, fruit, herb and vegetable wines; as well as beers, mead, cider, etc. Complete recipes, advice as to equipment, procedures such as fermenting, bottling, and storing wines. Recipes given in British, U. S., and metric measures. Accompanying booklet lists sources in U. S. A. where ingredients may be bought, and additional information. 11 illustrations. 157pp. 5⅝ x 8⅛. 22090-7 **Paperbound $2.00**

GARDENING WITH HERBS FOR FLAVOR AND FRAGRANCE, Helen M. Fox. How to grow herbs in your own garden, how to use them in your cooking (over 55 recipes included), legends and myths associated with each species, uses in medicine, perfumes, etc.—these are elements of one of the few books written especially for American herb fanciers. Guides you step-by-step from soil preparation to harvesting and storage for each type of herb. 12 drawings by Louise Mansfield. xiv + 334pp. 22540-2 Paperbound $2.50

AGAINST THE GRAIN (A REBOURS), Joris K. Huysmans. Filled with weird images, evidences of a bizarre imagination, exotic experiments with hallucinatory drugs, rich tastes and smells and the diversions of its sybarite hero Duc Jean des Esseintes, this classic novel pushed 19th-century literary decadence to its limits. Full unabridged edition. Do not confuse this with abridged editions generally sold. Introduction by Havelock Ellis. xlix + 206pp. 22190-3 Paperbound $2.50

VARIORUM SHAKESPEARE: HAMLET. Edited by Horace H. Furness; a landmark of American scholarship. Exhaustive footnotes and appendices treat all doubtful words and phrases, as well as suggested critical emendations throughout the play's history. First volume contains editor's own text, collated with all Quartos and Folios. Second volume contains full first Quarto, translations of Shakespeare's sources (Belleforest, and Saxo Grammaticus), Der Bestrafte Brudermord, and many essays on critical and historical points of interest by major authorities of past and present. Includes details of staging and costuming over the years. By far the best edition available for serious students of Shakespeare. Total of xx + 905pp. 21004-9, 21005-7, 2 volumes, Paperbound $7.00

A LIFE OF WILLIAM SHAKESPEARE, Sir Sidney Lee. This is the standard life of Shakespeare, summarizing everything known about Shakespeare and his plays. Incredibly rich in material, broad in coverage, clear and judicious, it has served thousands as the best introduction to Shakespeare. 1931 edition. 9 plates. xxix + 792pp. 21967-4 Paperbound $4.50

MASTERS OF THE DRAMA, John Gassner. Most comprehensive history of the drama in print, covering every tradition from Greeks to modern Europe and America, including India, Far East, etc. Covers more than 800 dramatists, 2000 plays, with biographical material, plot summaries, theatre history, criticism, etc. "Best of its kind in English," *New Republic*. 77 illustrations. xxii + 890pp.
20100-7 Clothbound **$10.00**

THE EVOLUTION OF THE ENGLISH LANGUAGE, George McKnight. The growth of English, from the 14th century to the present. Unusual, non-technical account presents basic information in very interesting form: sound shifts, change in grammar and syntax, vocabulary growth, similar topics. Abundantly illustrated with quotations. Formerly *Modern English in the Making*. xii + 590pp.
21932-1 Paperbound $3.50

AN ETYMOLOGICAL DICTIONARY OF MODERN ENGLISH, Ernest Weekley. Fullest, richest work of its sort, by foremost British lexicographer. Detailed word histories, including many colloquial and archaic words; extensive quotations. Do not confuse this with the Concise Etymological Dictionary, which is much abridged. Total of xxvii + 830pp. 6½ x 9¼.
21873-2, 21874-0 Two volumes, Paperbound $7.90

FLATLAND: A ROMANCE OF MANY DIMENSIONS, E. A. Abbott. Classic of science-fiction explores ramifications of life in a two-dimensional world, and what happens when a three-dimensional being intrudes. Amusing reading, but also useful as introduction to thought about hyperspace. Introduction by Banesh Hoffmann. 16 illustrations. xx + 103pp. 20001-9 Paperbound $1.00

EAST O' THE SUN AND WEST O' THE MOON, George W. Dasent. Considered the best of all translations of these Norwegian folk tales, this collection has been enjoyed by generations of children (and folklorists too). Includes True and Untrue, Why the Sea is Salt, East O' the Sun and West O' the Moon, Why the Bear is Stumpy-Tailed, Boots and the Troll, The Cock and the Hen, Rich Peter the Pedlar, and 52 more. The only edition with all 59 tales. 77 illustrations by Erik Werenskiold and Theodor Kittelsen. xv + 418pp. 22521-6 Paperbound $3.50

GOOPS AND HOW TO BE THEM, Gelett Burgess. Classic of tongue-in-cheek humor, masquerading as etiquette book. 87 verses, twice as many cartoons, show mischievous Goops as they demonstrate to children virtues of table manners, neatness, courtesy, etc. Favorite for generations. viii + 88pp. 6½ x 9¼.
22233-0 Paperbound $1.50

ALICE'S ADVENTURES UNDER GROUND, Lewis Carroll. The first version, quite different from the final *Alice in Wonderland,* printed out by Carroll himself with his own illustrations. Complete facsimile of the "million dollar" manuscript Carroll gave to Alice Liddell in 1864. Introduction by Martin Gardner. viii + 96pp. Title and dedication pages in color. 21482-6 Paperbound $1.25

THE BROWNIES, THEIR BOOK, Palmer Cox. Small as mice, cunning as foxes, exuberant and full of mischief, the Brownies go to the zoo, toy shop, seashore, circus, etc., in 24 verse adventures and 266 illustrations. Long a favorite, since their first appearance in St. Nicholas Magazine. xi + 144pp. 6⅝ x 9¼.
21265-3 Paperbound $1.75

SONGS OF CHILDHOOD, Walter De La Mare. Published (under the pseudonym Walter Ramal) when De La Mare was only 29, this charming collection has long been a favorite children's book. A facsimile of the first edition in paper, the 47 poems capture the simplicity of the nursery rhyme and the ballad, including such lyrics as I Met Eve, Tartary, The Silver Penny. vii + 106pp. (USO) 21972-0 Paperbound $1.25

THE COMPLETE NONSENSE OF EDWARD LEAR, Edward Lear. The finest 19th-century humorist-cartoonist in full: all nonsense limericks, zany alphabets, Owl and Pussycat, songs, nonsense botany, and more than 500 illustrations by Lear himself. Edited by Holbrook Jackson. xxix + 287pp. (USO) 20167-8 Paperbound $2.00

BILLY WHISKERS: THE AUTOBIOGRAPHY OF A GOAT, Frances Trego Montgomery. A favorite of children since the early 20th century, here are the escapades of that rambunctious, irresistible and mischievous goat—Billy Whiskers. Much in the spirit of *Peck's Bad Boy,* this is a book that children never tire of reading or hearing. All the original familiar illustrations by W. H. Fry are included: 6 color plates, 18 black and white drawings. 159pp. 22345-0 Paperbound $2.00

MOTHER GOOSE MELODIES. Faithful republication of the fabulously rare Munroe and Francis "copyright 1833" Boston edition—the most important Mother Goose collection, usually referred to as the "original." Familiar rhymes plus many rare ones, with wonderful old woodcut illustrations. Edited by E. F. Bleiler. 128pp. 4½ x 6⅜. 22577-1 Paperbound $1.00

"ESSENTIAL GRAMMAR" SERIES

All you really need to know about modern, colloquial grammar. Many educational shortcuts help you learn faster, understand better. Detailed cognate lists teach you to recognize similarities between English and foreign words and roots—make learning vocabulary easy and interesting. Excellent for independent study or as a supplement to record courses.

ESSENTIAL FRENCH GRAMMAR, Seymour Resnick. 2500-item cognate list. 159pp.
(EBE) 20419-7 Paperbound $1.50

ESSENTIAL GERMAN GRAMMAR, Guy Stern and Everett F. Bleiler. Unusual shortcuts on noun declension, word order, compound verbs. 124pp.
(EBE) 20422-7 Paperbound $1.25

ESSENTIAL ITALIAN GRAMMAR, Olga Ragusa. 111pp.
(EBE) 20779-X Paperbound $1.25

ESSENTIAL JAPANESE GRAMMAR, Everett F. Bleiler. In Romaji transcription; no characters needed. Japanese grammar is regular and simple. 156pp.
21027-8 Paperbound $1.50

ESSENTIAL PORTUGUESE GRAMMAR, Alexander da R. Prista. vi + 114pp.
21650-0 Paperbound $1.35

ESSENTIAL SPANISH GRAMMAR, Seymour Resnick. 2500 word cognate list. 115pp.
(EBE) 20780-3 Paperbound $1.25

ESSENTIAL ENGLISH GRAMMAR, Philip Gucker. Combines best features of modern, functional and traditional approaches. For refresher, class use, home study. x + 177pp.
21649-7 Paperbound $1.75

A PHRASE AND SENTENCE DICTIONARY OF SPOKEN SPANISH. Prepared for U. S. War Department by U. S. linguists. As above, unit is idiom, phrase or sentence rather than word. English-Spanish and Spanish-English sections contain modern equivalents of over 18,000 sentences. Introduction and appendix as above. iv + 513pp.
20495-2 Paperbound $3.50

A PHRASE AND SENTENCE DICTIONARY OF SPOKEN RUSSIAN. Dictionary prepared for U. S. War Department by U. S. linguists. Basic unit is not the word, but the idiom, phrase or sentence. English-Russian and Russian-English sections contain modern equivalents for over 30,000 phrases. Grammatical introduction covers phonetics, writing, syntax. Appendix of word lists for food, numbers, geographical names, etc. vi + 573 pp. 6⅛ x 9¼.
20496-0 Paperbound $5.50

CONVERSATIONAL CHINESE FOR BEGINNERS, Morris Swadesh. Phonetic system, beginner's course in Pai Hua Mandarin Chinese covering most important, most useful speech patterns. Emphasis on modern colloquial usage. Formerly *Chinese in Your Pocket*. xvi + 158pp.
21123-1 Paperbound $1.75

INCIDENTS OF TRAVEL IN YUCATAN, John L. Stephens. Classic (1843) exploration of jungles of Yucatan, looking for evidences of Maya civilization. Stephens found many ruins; comments on travel adventures, Mexican and Indian culture. 127 striking illustrations by F. Catherwood. Total of 669 pp.

20926-1, 20927-X Two volumes, Paperbound $5.50

INCIDENTS OF TRAVEL IN CENTRAL AMERICA, CHIAPAS, AND YUCATAN, John L. Stephens. An exciting travel journal and an important classic of archeology. Narrative relates his almost single-handed discovery of the Mayan culture, and exploration of the ruined cities of Copan, Palenque, Utatlan and others; the monuments they dug from the earth, the temples buried in the jungle, the customs of poverty-stricken Indians living a stone's throw from the ruined palaces. 115 drawings by F. Catherwood. Portrait of Stephens. xii + 812pp.

22404-X, 22405-8 Two volumes, Paperbound $6.00

A NEW VOYAGE ROUND THE WORLD, William Dampier. Late 17-century naturalist joined the pirates of the Spanish Main to gather information; remarkably vivid account of buccaneers, pirates; detailed, accurate account of botany, zoology, ethnography of lands visited. Probably the most important early English voyage, enormous implications for British exploration, trade, colonial policy. Also most interesting reading. Argonaut edition, introduction by Sir Albert Gray. New introduction by Percy Adams. 6 plates, 7 illustrations. xlvii + 376pp. 6½ x 9¼.

21900-3 Paperbound $3.00

INTERNATIONAL AIRLINE PHRASE BOOK IN SIX LANGUAGES, Joseph W. Bátor. Important phrases and sentences in English paralleled with French, German, Portuguese, Italian, Spanish equivalents, covering all possible airport-travel situations; created for airline personnel as well as tourist by Language Chief, Pan American Airlines. xiv + 204pp.

22017-6 Paperbound $2.25

STAGE COACH AND TAVERN DAYS, Alice Morse Earle. Detailed, lively account of the early days of taverns; their uses and importance in the social, political and military life; furnishings and decorations; locations; food and drink; tavern signs, etc. Second half covers every aspect of early travel; the roads, coaches, drivers, etc. Nostalgic, charming, packed with fascinating material. 157 illustrations, mostly photographs. xiv + 449pp.

22518-6 Paperbound $4.00

NORSE DISCOVERIES AND EXPLORATIONS IN NORTH AMERICA, Hjalmar R. Holand. The perplexing Kensington Stone, found in Minnesota at the end of the 19th century. Is it a record of a Scandinavian expedition to North America in the 14th century? Or is it one of the most successful hoaxes in history. A scientific detective investigation. Formerly *Westward from Vinland*. 31 photographs, 17 figures. x + 354pp.

22014-1 Paperbound $2.75

A BOOK OF OLD MAPS, compiled and edited by Emerson D. Fite and Archibald Freeman. 74 old maps offer an unusual survey of the discovery, settlement and growth of America down to the close of the Revolutionary war: maps showing Norse settlements in Greenland, the explorations of Columbus, Verrazano, Cabot, Champlain, Joliet, Drake, Hudson, etc., campaigns of Revolutionary war battles, and much more. Each map is accompanied by a brief historical essay. xvi + 299pp. 11 x 13¾.

22084-2 Paperbound $7.00

POEMS OF ANNE BRADSTREET, edited with an introduction by Robert Hutchinson. A new selection of poems by America's first poet and perhaps the first significant woman poet in the English language. 48 poems display her development in works of considerable variety—love poems, domestic poems, religious meditations, formal elegies, "quaternions," etc. Notes, bibliography. viii + 222pp.
22160-1 Paperbound $2.50

THREE GOTHIC NOVELS: THE CASTLE OF OTRANTO BY HORACE WALPOLE; VATHEK BY WILLIAM BECKFORD; THE VAMPYRE BY JOHN POLIDORI, WITH FRAGMENT OF A NOVEL BY LORD BYRON, edited by E. F. Bleiler. The first Gothic novel, by Walpole; the finest Oriental tale in English, by Beckford; powerful Romantic supernatural story in versions by Polidori and Byron. All extremely important in history of literature; all still exciting, packed with supernatural thrills, ghosts, haunted castles, magic, etc. xl + 291pp.
21232-7 Paperbound $3.00

THE BEST TALES OF HOFFMANN, E. T. A. Hoffmann. 10 of Hoffmann's most important stories, in modern re-editings of standard translations: Nutcracker and the King of Mice, Signor Formica, Automata, The Sandman, Rath Krespel, The Golden Flowerpot, Master Martin the Cooper, The Mines of Falun, The King's Betrothed, A New Year's Eve Adventure. 7 illustrations by Hoffmann. Edited by E. F. Bleiler. xxxix + 419pp.
21793-0 Paperbound $3.00

GHOST AND HORROR STORIES OF AMBROSE BIERCE, Ambrose Bierce. 23 strikingly modern stories of the horrors latent in the human mind: The Eyes of the Panther, The Damned Thing, An Occurrence at Owl Creek Bridge, An Inhabitant of Carcosa, etc., plus the dream-essay, Visions of the Night. Edited by E. F. Bleiler. xxii + 199pp.
20767-6 Paperbound $2.00

BEST GHOST STORIES OF J. S. LEFANU, J. Sheridan LeFanu. Finest stories by Victorian master often considered greatest supernatural writer of all. Carmilla, Green Tea, The Haunted Baronet, The Familiar, and 12 others. Most never before available in the U. S. A. Edited by E. F. Bleiler. 8 illustrations from Victorian publications. xvii + 467pp.
20415-4 Paperbound $3.00

MATHEMATICAL FOUNDATIONS OF INFORMATION THEORY, A. I. Khinchin. Comprehensive introduction to work of Shannon, McMillan, Feinstein and Khinchin, placing these investigations on a rigorous mathematical basis. Covers entropy concept in probability theory, uniqueness theorem, Shannon's inequality, ergodic sources, the E property, martingale concept, noise, Feinstein's fundamental lemma, Shanon's first and second theorems. Translated by R. A. Silverman and M. D. Friedman. iii + 120pp.
60434-9 Paperbound $2.00

SEVEN SCIENCE FICTION NOVELS, H. G. Wells. The standard collection of the great novels. Complete, unabridged. First Men in the Moon, Island of Dr. Moreau, War of the Worlds, Food of the Gods, Invisible Man, Time Machine, In the Days of the Comet. Not only science fiction fans, but every educated person owes it to himself to read these novels. 1015pp. (USO) 20264-X Clothbound $6.00

THE ARCHITECTURE OF COUNTRY HOUSES, Andrew J. Downing. Together with Vaux's *Villas and Cottages* this is the basic book for Hudson River Gothic architecture of the middle Victorian period. Full, sound discussions of general aspects of housing, architecture, style, decoration, furnishing, together with scores of detailed house plans, illustrations of specific buildings, accompanied by full text. Perhaps the most influential single American architectural book. 1850 edition. Introduction by J. Stewart Johnson. 321 figures, 34 architectural designs. xvi + 560pp.
22003-6 Paperbound $5.00

LOST EXAMPLES OF COLONIAL ARCHITECTURE, John Mead Howells. Full-page photographs of buildings that have disappeared or been so altered as to be denatured, including many designed by major early American architects. 245 plates. xvii + 248pp. 7⅞ x 10¾.
21143-6 Paperbound $3.50

DOMESTIC ARCHITECTURE OF THE AMERICAN COLONIES AND OF THE EARLY REPUBLIC, Fiske Kimball. Foremost architect and restorer of Williamsburg and Monticello covers nearly 200 homes between 1620-1825. Architectural details, construction, style features, special fixtures, floor plans, etc. Generally considered finest work in its area. 219 illustrations of houses, doorways, windows, capital mantels. xx + 314pp. 7⅞ x 10¾.
21743-4 Paperbound $4.00

EARLY AMERICAN ROOMS: 1650-1858, edited by Russell Hawes Kettell. Tour of 12 rooms, each representative of a different era in American history and each furnished, decorated, designed and occupied in the style of the era. 72 plans and elevations, 8-page color section, etc., show fabrics, wall papers, arrangements, etc. Full descriptive text. xvii + 200pp. of text. 8⅜ x 11¼.
21633-0 Paperbound $5.00

THE FITZWILLIAM VIRGINAL BOOK, edited by J. Fuller Maitland and W. B. Squire. Full modern printing of famous early 17th-century ms. volume of 300 works by Morley, Byrd, Bull, Gibbons, etc. For piano or other modern keyboard instrument; easy to read format. xxxvi + 938pp. 8⅜ x 11.
21068-5, 21069-3 Two volumes, Paperbound $12.00

KEYBOARD MUSIC, Johann Sebastian Bach. Bach Gesellschaft edition. A rich selection of Bach's masterpieces for the harpsichord: the six English Suites, six French Suites, the six Partitas (Clavierübung part I), the Goldberg Variations (Clavierübung part IV), the fifteen Two-Part Inventions and the fifteen Three-Part Sinfonias. Clearly reproduced on large sheets with ample margins; eminently playable. vi + 312pp. 8⅛ x 11.
22360-4 Paperbound $5.00

THE MUSIC OF BACH: AN INTRODUCTION, Charles Sanford Terry. A fine, nontechnical introduction to Bach's music, both instrumental and vocal. Covers organ music, chamber music, passion music, other types. Analyzes themes, developments, innovations. x + 114pp.
21075-8 Paperbound $1.95

BEETHOVEN AND HIS NINE SYMPHONIES, Sir George Grove. Noted British musicologist provides best history, analysis, commentary on symphonies. Very thorough, rigorously accurate; necessary to both advanced student and amateur music lover. 436 musical passages. vii + 407 pp.
20334-4 Paperbound $4.00

THE PHILOSOPHY OF THE UPANISHADS, Paul Deussen. Clear, detailed statement of upanishadic system of thought, generally considered among best available. History of these works, full exposition of system emergent from them, parallel concepts in the West. Translated by A. S. Geden. xiv + 429pp.

21616-0 Paperbound $3.50

LANGUAGE, TRUTH AND LOGIC, Alfred J. Ayer. Famous, remarkably clear introduction to the Vienna and Cambridge schools of Logical Positivism; function of philosophy, elimination of metaphysical thought, nature of analysis, similar topics. "Wish I had written it myself," Bertrand Russell. 2nd, 1946 edition. 160pp.

20010-8 Paperbound $1.50

THE GUIDE FOR THE PERPLEXED, Moses Maimonides. Great classic of medieval Judaism, major attempt to reconcile revealed religion (Pentateuch, commentaries) and Aristotelian philosophy. Enormously important in all Western thought. Unabridged Friedländer translation. 50-page introduction. lix + 414pp.

(USO) 20351-4 Paperbound $4.50

OCCULT AND SUPERNATURAL PHENOMENA, D. H. Rawcliffe. Full, serious study of the most persistent delusions of mankind: crystal gazing, mediumistic trance, stigmata, lycanthropy, fire walking, dowsing, telepathy, ghosts, ESP, etc., and their relation to common forms of abnormal psychology. Formerly *Illusions and Delusions of the Supernatural and the Occult.* iii + 551pp. 20503-7 Paperbound $4.00

THE EGYPTIAN BOOK OF THE DEAD: THE PAPYRUS OF ANI, E. A. Wallis Budge. Full hieroglyphic text, interlinear transliteration of sounds, word for word translation, then smooth, connected translation; Theban recension. Basic work in Ancient Egyptian civilization; now even more significant than ever for historical importance, dilation of consciousness, etc. clvi + 377pp. 6½ x 9¼.

21866-X Paperbound $4.95

PSYCHOLOGY OF MUSIC, Carl E. Seashore. Basic, thorough survey of everything known about psychology of music up to 1940's; essential reading for psychologists, musicologists. Physical acoustics; auditory apparatus; relationship of physical sound to perceived sound; role of the mind in sorting, altering, suppressing, creating sound sensations; musical learning, testing for ability, absolute pitch, other topics. Records of Caruso, Menuhin analyzed. 88 figures. xix + 408pp.

21851-1 Paperbound $3.50

THE I CHING (THE BOOK OF CHANGES), translated by James Legge. Complete translated text plus appendices by Confucius, of perhaps the most penetrating divination book ever compiled. Indispensable to all study of early Oriental civilizations. 3 plates. xxiii + 448pp. 21062-6 Paperbound $3.50

THE UPANISHADS, translated by Max Müller. Twelve classical upanishads: Chandogya, Kena, Aitareya, Kaushitaki, Isa, Katha, Mundaka, Taittiriyaka, Brhadaranyaka, Svetasvatara, Prasna, Maitriyana. 160-page introduction, analysis by Prof. Müller. Total of 670pp. 20992-X, 20993-8 Two volumes, Paperbound $7.50

THE PRINCIPLES OF PSYCHOLOGY, William James. The famous long course, complete and unabridged. Stream of thought, time perception, memory, experimental methods—these are only some of the concerns of a work that was years ahead of its time and still valid, interesting, useful. 94 figures. Total of xviii + 1391pp.
20381-6, 20382-4 Two volumes, Paperbound $9.00

THE STRANGE STORY OF THE QUANTUM, Banesh Hoffmann. Non-mathematical but thorough explanation of work of Planck, Einstein, Bohr, Pauli, de Broglie, Schrödinger, Heisenberg, Dirac, Feynman, etc. No technical background needed. "Of books attempting such an account, this is the best," Henry Margenau, Yale. 40-page "Postscript 1959." xii + 285pp.
20518-5 Paperbound $3.00

THE RISE OF THE NEW PHYSICS, A. d'Abro. Most thorough explanation in print of central core of mathematical physics, both classical and modern; from Newton to Dirac and Heisenberg. Both history and exposition; philosophy of science, causality, explanations of higher mathematics, analytical mechanics, electromagnetism, thermodynamics, phase rule, special and general relativity, matrices. No higher mathematics needed to follow exposition, though treatment is elementary to intermediate in level. Recommended to serious student who wishes verbal understanding. 97 illustrations. xvii + 982pp.
20003-5, 20004-3 Two volumes, Paperbound $10.00

GREAT IDEAS OF OPERATIONS RESEARCH, Jagjit Singh. Easily followed non-technical explanation of mathematical tools, aims, results: statistics, linear programming, game theory, queueing theory, Monte Carlo simulation, etc. Uses only elementary mathematics. Many case studies, several analyzed in detail. Clarity, breadth make this excellent for specialist in another field who wishes background. 41 figures. x + 228pp.
21886-4 Paperbound $2.50

GREAT IDEAS OF MODERN MATHEMATICS: THEIR NATURE AND USE, Jagjit Singh. Internationally famous expositor, winner of Unesco's Kalinga Award for science popularization explains verbally such topics as differential equations, matrices, groups, sets, transformations, mathematical logic and other important modern mathematics, as well as use in physics, astrophysics, and similar fields. Superb exposition for layman, scientist in other areas. viii + 312pp.
20587-8 Paperbound $2.75

GREAT IDEAS IN INFORMATION THEORY, LANGUAGE AND CYBERNETICS, Jagjit Singh. The analog and digital computers, how they work, how they are like and unlike the human brain, the men who developed them, their future applications, computer terminology. An essential book for today, even for readers with little math. Some mathematical demonstrations included for more advanced readers. 118 figures. Tables. ix + 338pp.
21694-2 Paperbound $2.50

CHANCE, LUCK AND STATISTICS, Horace C. Levinson. Non-mathematical presentation of fundamentals of probability theory and science of statistics and their applications. Games of chance, betting odds, misuse of statistics, normal and skew distributions, birth rates, stock speculation, insurance. Enlarged edition. Formerly "The Science of Chance." xiii + 357pp.
21007-3 Paperbound $2.50

MATHEMATICAL PUZZLES FOR BEGINNERS AND ENTHUSIASTS, Geoffrey Mott-Smith. 189 puzzles from easy to difficult—involving arithmetic, logic, algebra, properties of digits, probability, etc.—for enjoyment and mental stimulus. Explanation of mathematical principles behind the puzzles. 135 illustrations. viii + 248pp.
20198-8 Paperbound $2.00

PAPER FOLDING FOR BEGINNERS, William D. Murray and Francis J. Rigney. Easiest book on the market, clearest instructions on making interesting, beautiful origami. Sail boats, cups, roosters, frogs that move legs, bonbon boxes, standing birds, etc. 40 projects; more than 275 diagrams and photographs. 94pp.
20713-7 Paperbound $1.00

TRICKS AND GAMES ON THE POOL TABLE, Fred Herrmann. 79 tricks and games— some solitaires, some for two or more players, some competitive games—to entertain you between formal games. Mystifying shots and throws, unusual caroms, tricks involving such props as cork, coins, a hat, etc. Formerly *Fun on the Pool Table*. 77 figures. 95pp.
21814-7 Paperbound $1.25

HAND SHADOWS TO BE THROWN UPON THE WALL: A SERIES OF NOVEL AND AMUSING FIGURES FORMED BY THE HAND, Henry Bursill. Delightful picturebook from great-grandfather's day shows how to make 18 different hand shadows: a bird that flies, duck that quacks, dog that wags his tail, camel, goose, deer, boy, turtle, etc. Only book of its sort. vi + 33pp. 6½ x 9¼. 21779-5 Paperbound $1.00

WHITTLING AND WOODCARVING, E. J. Tangerman. 18th printing of best book on market. "If you can cut a potato you can carve" toys and puzzles, chains, chessmen, caricatures, masks, frames, woodcut blocks, surface patterns, much more. Information on tools, woods, techniques. Also goes into serious wood sculpture from Middle Ages to present, East and West. 464 photos, figures. x + 293pp.
20965-2 Paperbound $2.50

HISTORY OF PHILOSOPHY, Julián Marias. Possibly the clearest, most easily followed, best planned, most useful one-volume history of philosophy on the market; neither skimpy nor overfull. Full details on system of every major philosopher and dozens of less important thinkers from pre-Socratics up to Existentialism and later. Strong on many European figures usually omitted. Has gone through dozens of editions in Europe. 1966 edition, translated by Stanley Appelbaum and Clarence Strowbridge. xviii + 505pp. 21739-6 Paperbound $3.50

YOGA: A SCIENTIFIC EVALUATION, Kovoor T. Behanan. Scientific but non-technical study of physiological results of yoga exercises; done under auspices of Yale U. Relations to Indian thought, to psychoanalysis, etc. 16 photos. xxiii + 270pp.
20505-3 Paperbound $2.50

Prices subject to change without notice.
Available at your book dealer or write for free catalogue to Dept. GI, Dover Publications, Inc., 180 Varick St., N. Y., N. Y. 10014. Dover publishes more than 150 books each year on science, elementary and advanced mathematics, biology, music, art, literary history, social sciences and other areas.